Helen Langdon

EVERYDAY-LIFE PAINTING

PHAIDON

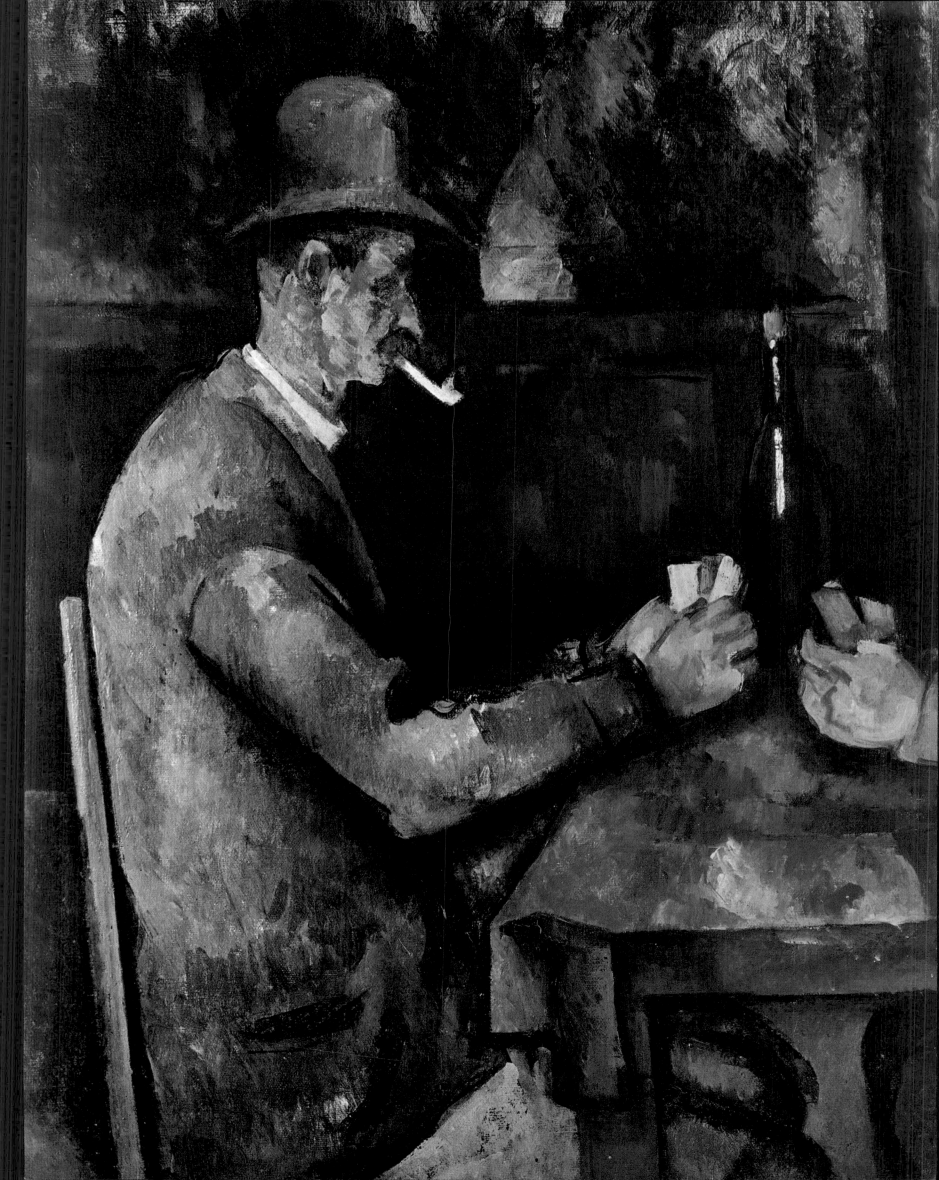

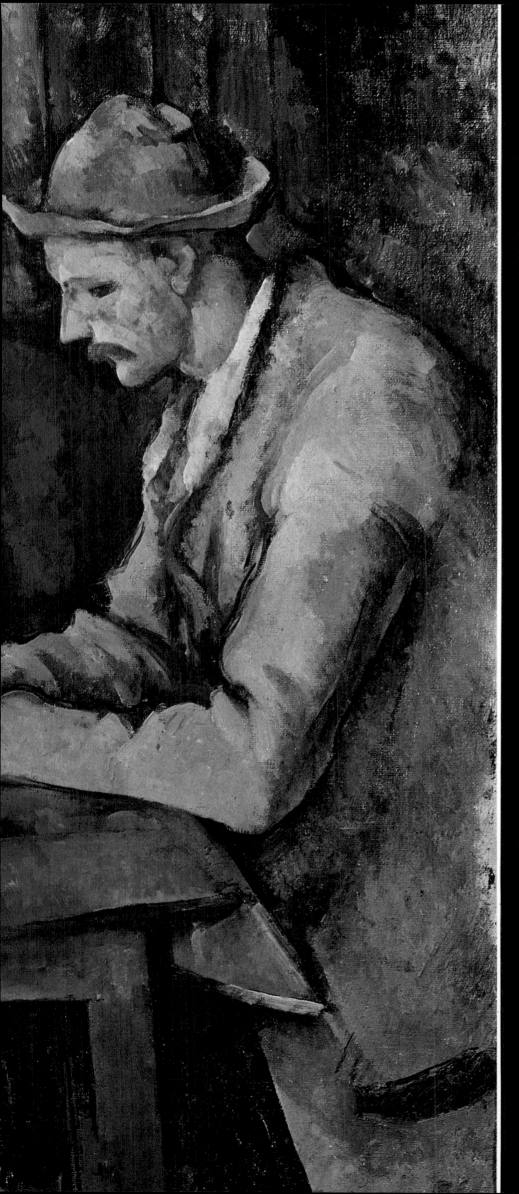

Helen Langdon

EVERYDA
LIFE
PAINTING

OVERLEAF **Cézanne**: *The Card Players*, 47·5 × 57cm, 1890–2

PHAIDON PRESS LIMITED

Littlegate House, St Ebbe's Street, Oxford

© TEXT 1979 Phaidon Press Limited
© DESIGN 1979 Heraclio Fournier, S. A.

The film positives of the illustrations are
the property of Heraclio Fournier, S. A.

British Library Cataloguing in Publication Data

 LANGDON, HELEN
 Everyday-life painting. – (Phaidon gallery).
 1. Genre painting, European
 I. Title
 754'.094 ND1450

 ISBN 0–7148–1993–X
 ISBN 0–7148–1928–X Pbk

Printed and bound in Spain by HERACLIO FOURNIER SA, *Vitoria*
Filmset in England by SOUTHERN POSITIVES AND NEGATIVES
(SPAN), *Lingfield, Surrey*

Everyday-Life Painting

IN HIS FAMOUS ACCOUNT of the paintings of antiquity Pliny the Elder, who perished in the eruption of Vesuvius in AD79, tells us of a Greek painter, Peiraikos, who

> won fame with the brush in painting smaller pictures . . . In mastery of his art but few rank above him, yet by his choice of a path he perhaps marred his own success, for he followed a humble line, winning however the highest glory that it had to bring. He painted barbers' shops, cobblers' stalls, asses, eatables and similar subjects, earning for himself the name of painter of odds and ends. In these subjects he could give consummate pleasure, selling them for more than other artists recorded for their large pictures.

Pliny's account tells us how far Greek artists had advanced along the path of modern naturalism; it also reveals that Pliny was uneasy about these humble subjects from everyday life. The great painters of the Renaissance, concerned to establish painting as a liberal art, adopted Pliny's attitude. They developed the aesthetic doctrine that painting should represent human action as completely as a poem and for the same didactic end. The artist should, therefore, choose sublime and uplifting themes from the Bible, classical history, poetry or mythology, which, as Sir Joshua Reynolds remarked, 'early education and the universal course of reading have made familiar and interesting to all Europe without being degraded by the vulgarism of ordinary life in any country.'

By the seventeenth century, particularly in England and France, this classic theory of art had become strictly codified; after the foundation of the French Academy, when Lebrun and Boileau became absolute arbiters of art and letters, a rigid hierarchy of values was established. The noble art of history painting held pride of place; at the bottom were the vulgar art forms of still-life, landscape and scenes from everyday life, categories traditionally associated with such 'low class painters as the Hollanders'.

The history of paintings of everyday life is then, in some respects, the history of a struggle for recognition of the intellectual dignity of such subjects. It is a tradition that has produced those grave and moving assertions of human dignity by Velazquez, Louis Le Nain and Georges de La Tour, and those intensely personal paintings by Watteau, Piazzetta and Picasso, in which materials of reality are transformed into a strange and imaginative world. At the same time paintings of everyday life have been very much the province of the specialist minor masters, who developed their own formal and iconographic conventions and whose repetition of a limited range of subjects is far from being a spontaneous reaction against the formalism of the grand manner. Certain themes – the life of the peasant, the tavern scene, the brothel – recur throughout its history. A possible

way of illuminating and pinpointing the interests of artists at different periods is to trace the development of such themes.

In the sixteenth century paintings of the courtesan were satirical warnings against the danger of deadly sin. By the seventeenth century artists had become more concerned with a realistic portrayal of manners and social context, and themes range from the robustly humorous admonitions of Jan Steen to the subtle unveiling of bourgeois vice by Gerard ter Borch. Hogarth's treatment of the prostitute is loaded with brutal social comment; a century later, Degas

Aertsen: *The Kitchen Maid,* 127·5 × 82cm, 1559

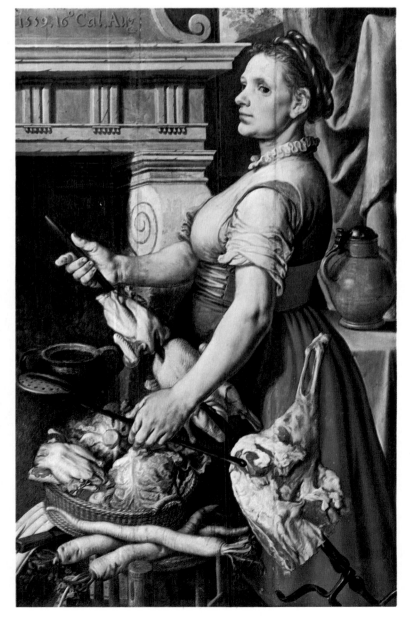

Campin: *St Barbara*, 101 × 47cm, 1438
Van Eyck: *Portrait of Giovanni Arnolfini and his Wife,
Giovanna Cenami*, 81·8 × 59·7cm, 1434 (Pages 8–9)
Antonello da Messina: *St Jerome in his Study*,
45 × 36cm, c.1460

David: *Virgin with a Bowl of Milk*, 35 × 29cm, c. 1517

Before the sixteenth century there was little interest in
secular subject matter for its own sake. These four
works show the way that artists began to include their
observations of everyday life in religious paintings and
portraits. From early in the fifteenth century painters
attempted to make religious stories relevant by treating
them as incidents of ordinary life. St Barbara is in a
comfortable Flemish interior, and Campin has studied
every detail with all the intensity of a still-life painter;
the saint's attribute, a tower, is part of the tranquil view
through the window. Antonello's St Jerome is sur-
rounded by the objects of his daily life, which, although
retaining a symbolic significance, are absorbed into a
naturalistic context. Such fifteenth-century paintings of
saints are the precursors of the numerous paintings of
scientists, alchemists, geographers and scholars that
became very popular in the seventeenth century.
Gerard David's *Virgin with a Bowl of Milk* strips the
religious image of obvious references to the divine
subject; it is an intimate and homely scene. The two
figures are surrounded by reassuringly material objects,
and the Christ Child is taking a healthy interest in his
plain meal; the sense of domestic peace is mirrored in
the landscape. Jan van Eyck's Arnolfini portrait is the
first time a private domestic scene is made the subject
of art. Although the objects are charged with symbol-
ism, the painting looks immediately naturalistic. The
clear sense of every object being in its place, and the
beauty of the light falling on the commonplace things
in the room give the work its feeling of overwhelming
reality.

drew the interior of a brothel with a cold and precise irony.
This exploration of man's lowest instincts is an alternative
tradition to the sublimation of those instincts that is found
in paintings of the ideal beauty of Venus. The prostitute's
finery and alluring unveiling of flesh contrast with the ideal
form of the nude Venus. Yet in 1863 Manet's *Olympia*
translated the pictorial type of a Titianesque Venus to the
boudoir of a young prostitute, startlingly nude and indi-
vidual; she represents the fusion of two traditions, those of
ideal and realistic art. From the middle of the nineteenth
century the classical distinctions between artistic strata were
retreating on all fronts.

In the Middle Ages, when art was essentially religious,
Gothic artists remained uninterested in the representation
of things for their own sake; the portable easel paintings
described by Pliny were not re-introduced until the fifteenth
century. During the Renaissance artists again became
interested in describing the appearance of the physical
world; the interiors of Giotto and other artists of the four-
teenth century contain naturalistic scenes of everyday life
within the context of religious art. It was, however, in
northern Europe at the beginning of the fifteenth century —
a hundred years later than Giotto — that Robert Campin's

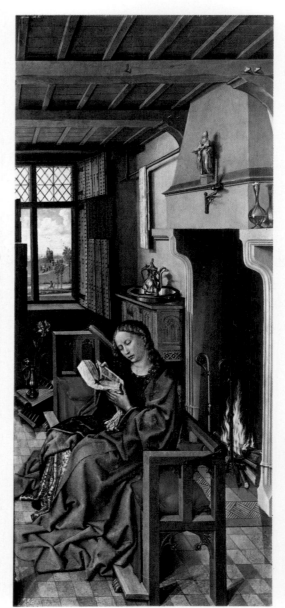

FAR LEFT
David: *Virgin
with a Bowl
of Milk*

LEFT **Campin:**
St Barbara

RIGHT
**Antonello da
Messina:** *St
Jerome in his
Study*

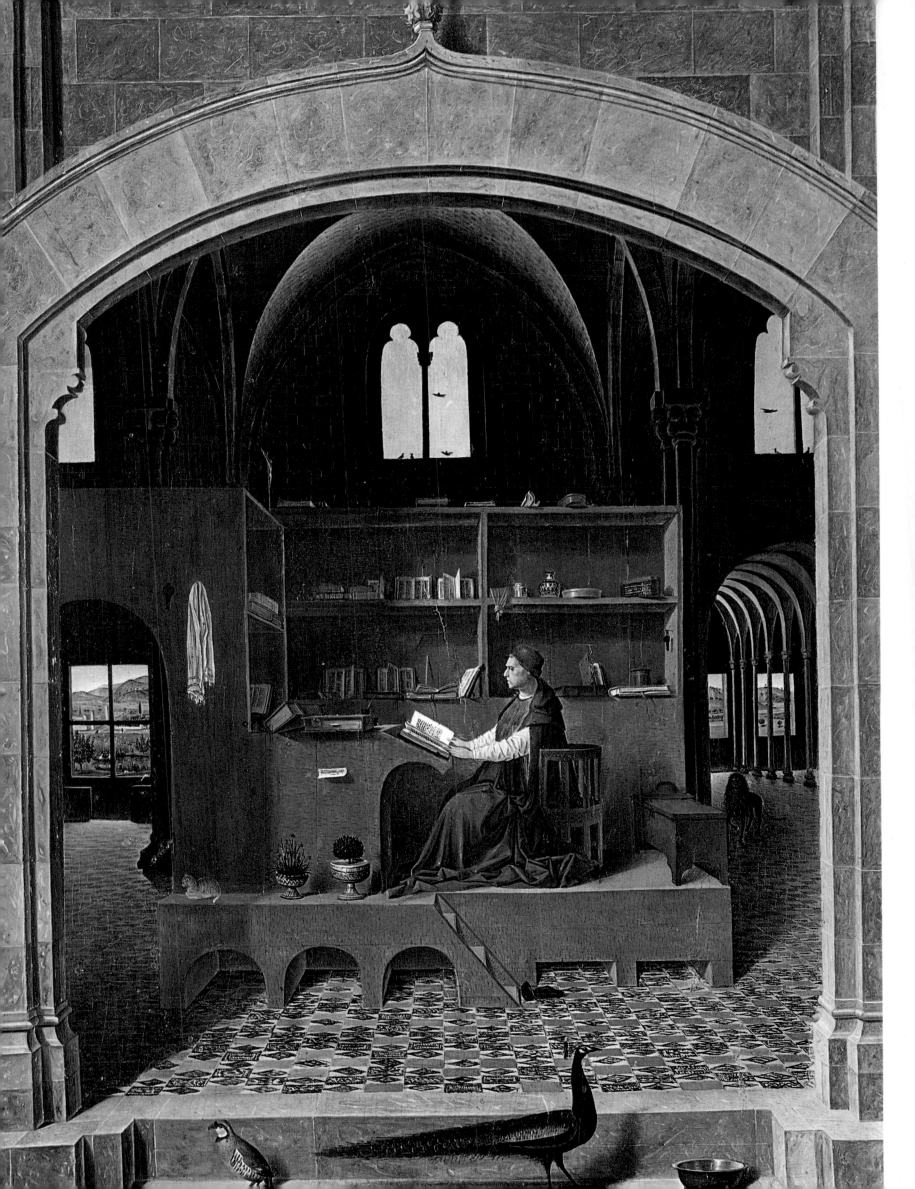

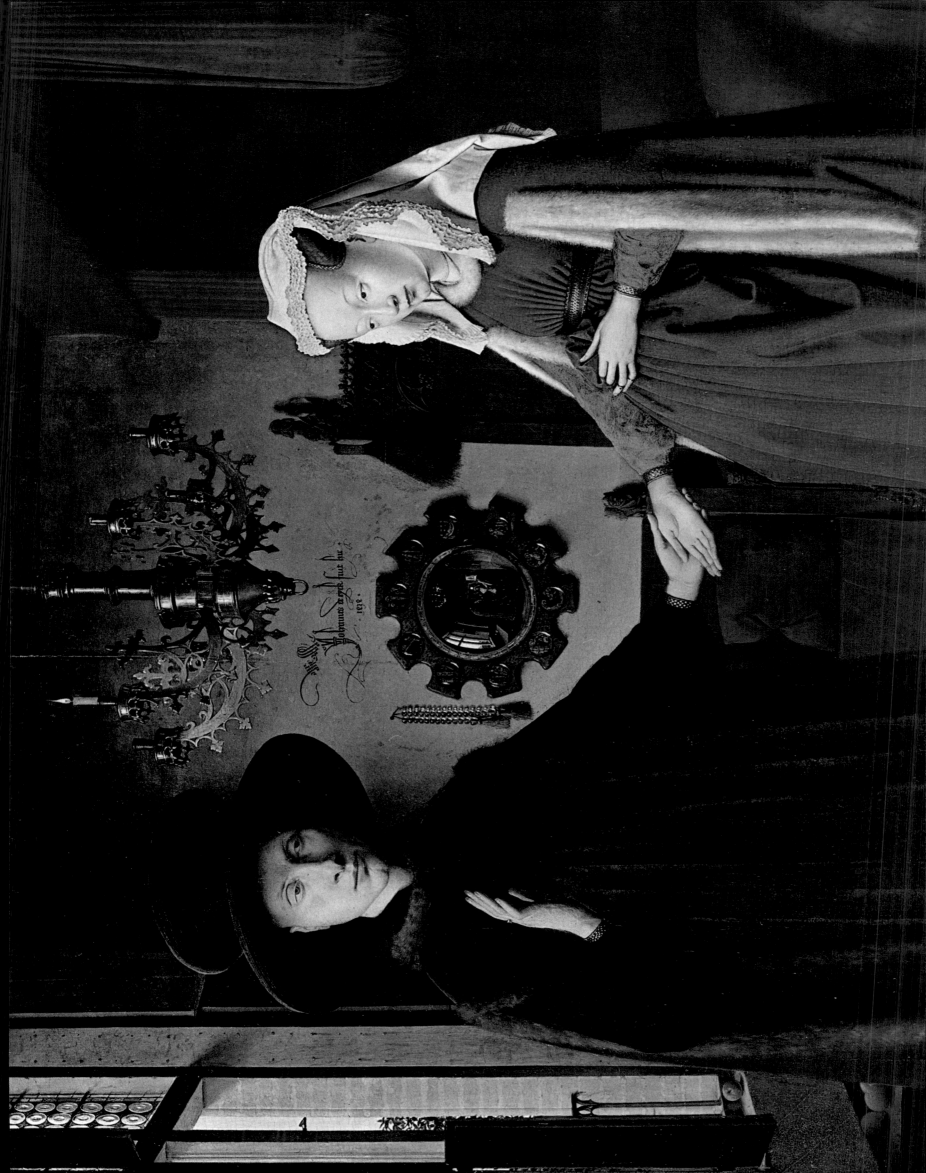

Van Eyck: *Portrait of Giovanni Arnolfini and his Wife, Giovanna Cenami*

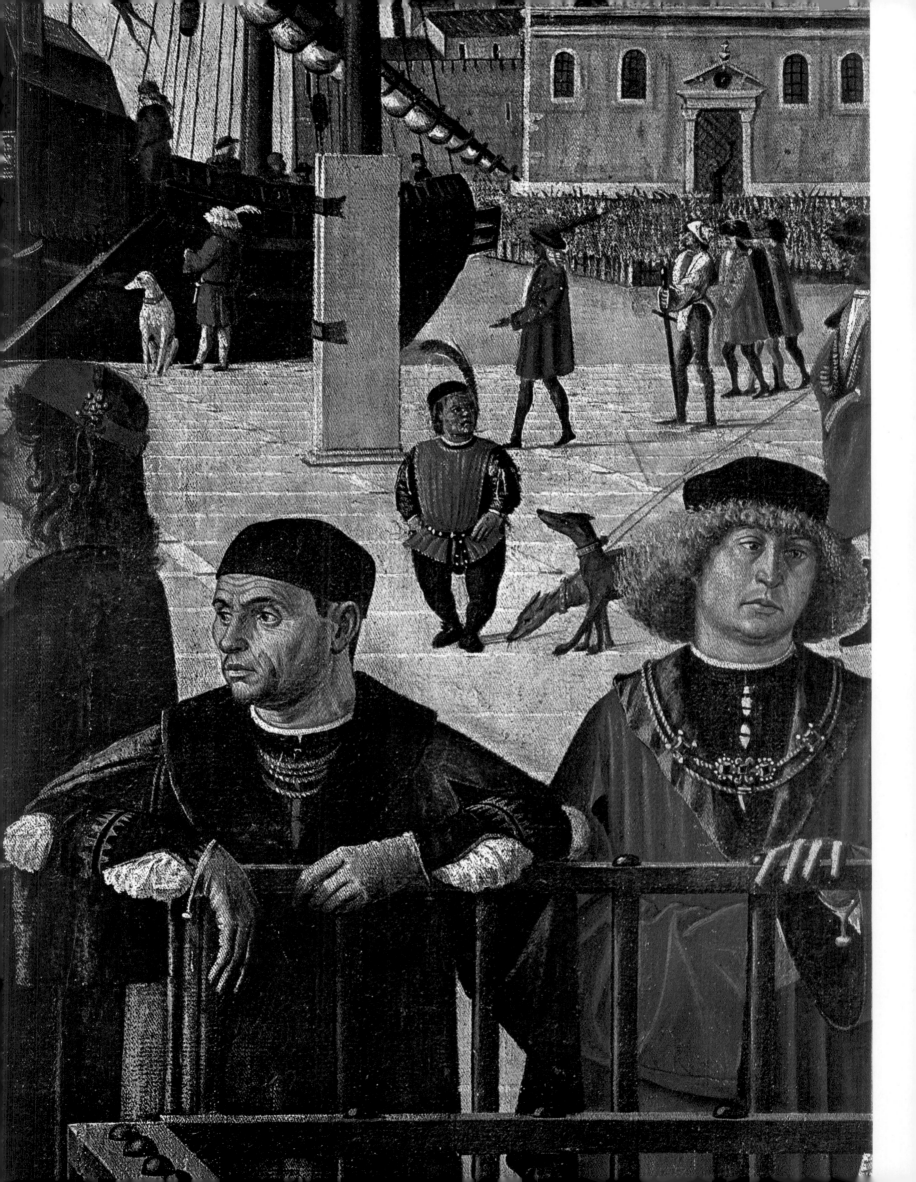

and Jan van Eyck's passionate interest in visual realism, in recording an infinite richness of detail and in capturing the beauty of surface and texture of flowers, jewels, fabrics, and materials led them to paint domestic interiors and enchanting glimpses of the life of the street. They are scenes that seem directly to anticipate the paintings of Pieter de Hooch and Vermeer. The religious works of Campin no longer had the gold backgrounds and abstract symbols of medieval art; he looked at the world around him for material to make the scenes of the gospel as easily comprehensible and as relevant as scenes from ordinary life. In his *St Barbara* the saint sits before the fire in a comfortable Flemish room; the painting is one of the earliest attempts to create a convincing, interior space, and the eye is led gently back through a succession of lovingly observed objects. The religious symbolism is absorbed into a context of descriptive naturalism. Jan van Eyck's astonishing technical virtuosity and love of multiplicity of tiny detail won him fame throughout Europe. The Neapolitan humanist, Bartolommeo Fazio, in his *Book of Famous Men*, described a painting by van Eyck of naked women in the bath. It showed women getting out of the bath 'and of one of them he has shown only the face and breast but has then presented the hind part of her

body in a mirror painted on the wall opposite'. There was 'a lantern in the bath chamber, just like one lit, and an old woman seemingly sweating, a puppy lapping up water, and also horses, minute figures of men, mountains, groves, hamlets and castles carried out with such skill you would believe one was fifty miles distant from another'. The painting is now lost, and we cannot be sure that it did not have a classical theme, yet it is at least possible that this is the earliest recorded instance of a purely secular subject. The painting, *Giovanni Arnolfini and his Wife* (1434), shows a similar use of a mirror; the perfectly focused and intimate domestic scene must have seemed a miracle of illusionism.

In the early sixteenth century there was an awakening interest in the secular world. A reforming zeal inspired both writers and artists to ridicule, warn and rebuke – Sebastian Brant's *The Ship of Fools*, 1494, paraded human error with a tart and scornful realism, and in 1509 Erasmus wrote the most famous satirical treatment of the theme of folly, the humane and ironic *In Praise of Folly*. In both prints and paintings man's greed, selfishness, lust and pride were castigated. Corrupt monks and nuns, charlatans and quacks and their gullible victims, were the target of Jerome Bosch's satire. Bosch's theme is that of the perils that this world

Carpaccio: *The Arrival of the English Ambassadors*, and detail, (OPPOSITE) c.1495

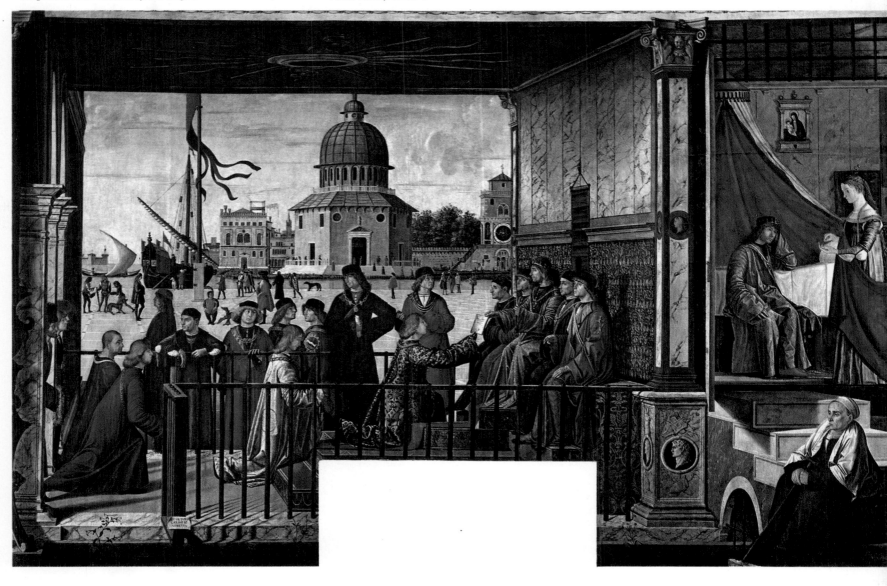

Bosch: *Tabletop of the Seven Deadly Sins and the Four Last Things*, 120 × 150cm, c.1485–1500

Scenes from everyday life here illustrate the Seven Deadly Sins; the rings in the centre represent the eye of God, and in the pupil, encircled by the words 'Beware, beware, God Sees', Christ displays his wounds. In the four smaller circles Death, the Last Judgment, Heaven and Hell indicate the sinner's fate. Bosch saw all human activity as a weak struggle against the overriding power of evil. The little scenes are fresh and lively and reveal some acute psychological observations. In other secular works Bosch castigated with real shrewdness varieties of human folly, gullibility, avarice, quackery and loose-living monks and nuns.

holds for the unwary and the rewards and penalties in the life to come. In the *Tabletop* the watchful eye of God surveys little scenes from everyday life that illustrate the seven deadly sins. To Bosch, man's sojourn in this world was that of an exile. The later painter, Quentin Metsys, represented human error without recourse to devils and spectres and moved from the almost religious solemnity and delicate psychological balance of *The Money Changer and his Wife* to an increasingly worldly satire. His grotesque parodies of lust, avarice and pride exploit to the full the harsh contrasts of age and youth, beauty and deformity. A contemporary saying ran, 'A usurer, a miller, a money-changer and a tax-collector are the devil's four evangelists' and Marinus van Reymerswaele's paintings of bankers and tax collectors depict grotesquely exaggerated figures, which are biting condemnations of greed and avarice. His grasping, withered

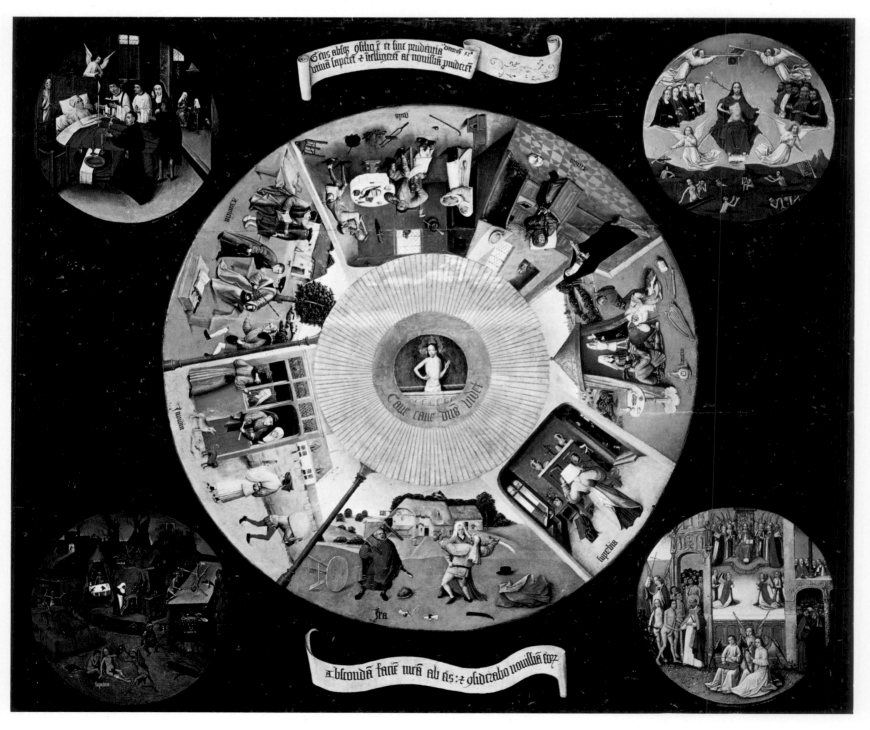

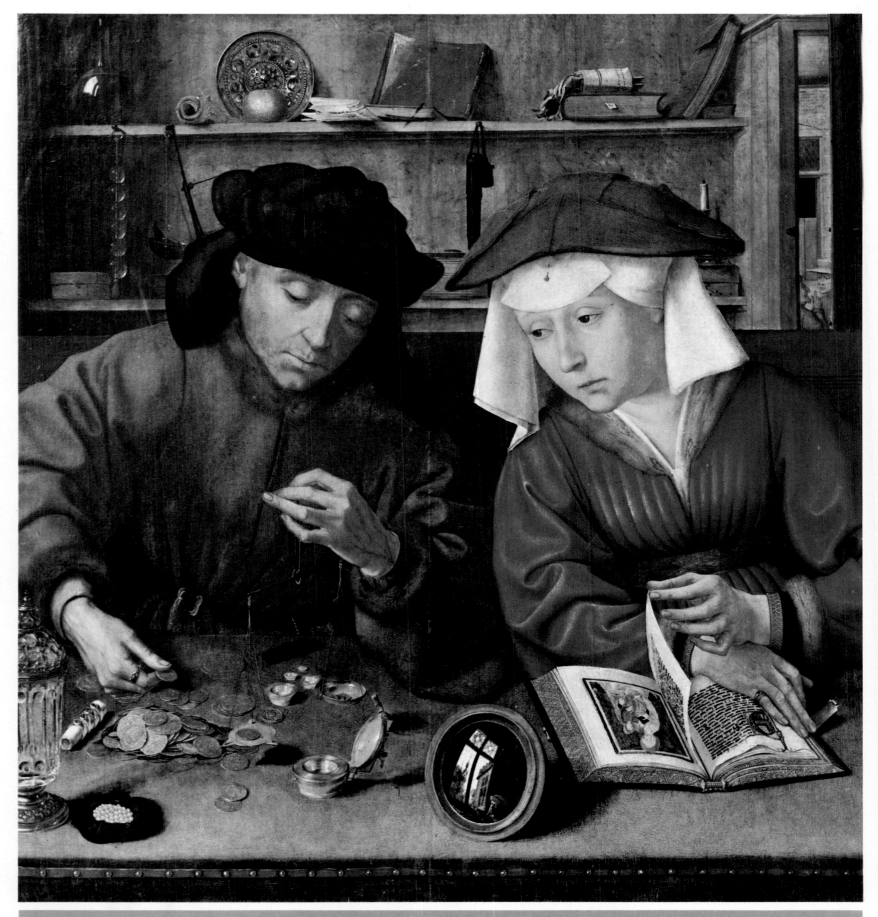

Metsys: *The Money Changer and his Wife*, 74 × 68cm, 1514

This painting retains something of the still and religious solemnity of van Eyck's *Arnolfini Marriage*, and may have been suggested by an Eyckian prototype. It has none of the harsh satire, sharp contrasts or grotesque types of Metsys' later secular works, and shows an unusual psychological delicacy. Yet the painting is not a portrait — the two figures are dressed in archaic costume — and it makes a subtle moral point. The wife is distracted from her prayer-book, as she casually flicks over a miniature of the Virgin and Child, by her husband's worldly concerns. In the mirror the reflection of a man reading before a window and a distant view of a church suggests the ideal of a contemplative life that warns against false values. But the man's quiet concentration on his job is not derided; the painting perhaps stresses the need for a careful balance between the spiritual and the worldly. In about 1522–3 Metsys introduced into Flemish art the theme of the 'Ill-Matched Pair', the contrast between senile lust and avaricious, youthful beauty. It was a theme especially favoured by Lucas Cranach and became very popular in German art and literature in the 1520s.

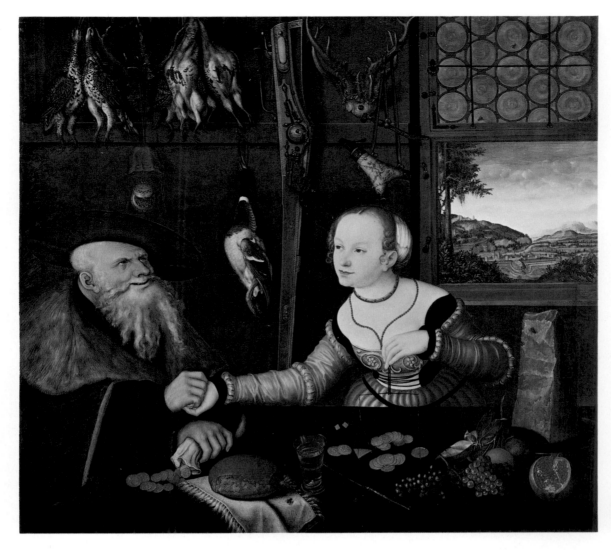

Lucas Cranach: *The Payment*, 108 × 119cm, 1532

and obsessed figures are submerged in the temptations of their profession – jumbled piles of contracts, registers, and the gold gleam of coins.

In Italy there was no tradition of this kind of didactic painting using the materials of ordinary life. In northern Italy many artists, influenced by the Arcadian movement in

Italian poetry, chose subjects that embodied a courtly ideal of graciousness and contemplative leisure. They painted concerts, or elegant musical parties, perhaps at the court of Caterina Cornaro, subjects that suggest a highly civilized life led in the pleasantest surroundings possible. They painted the out-of-door pleasures of villa life, scenes of

Marinus van Reymerswaele: *The Banker and his Wife*, 79 × 107cm, 1538

Marinus seems to have confined himself to a few themes, such as those of the tax collectors, St Jerome, and the banker and his wife. This painting derives from Metsys' version of 1514 but introduces some important new qualities. It has lost the religious overtones and the suggestion of a solemn devotional image and has become more worldly, more fully concerned with a new and secular subject. The banker's wife no longer leafs through the pages of a Book of Hours but has her hands firmly on a cash book; she leans forward avidly towards the gold. The banker's expression is drier and less attractive than the careful attentiveness shown by Metsys; he wears an extravagant, archaic hat which serves to alienate him further from the world of the spectator. Yet, compared with Marinus' later portrayals of grotesque ugliness and wildly fanciful costume, this is a restrained and humane work.

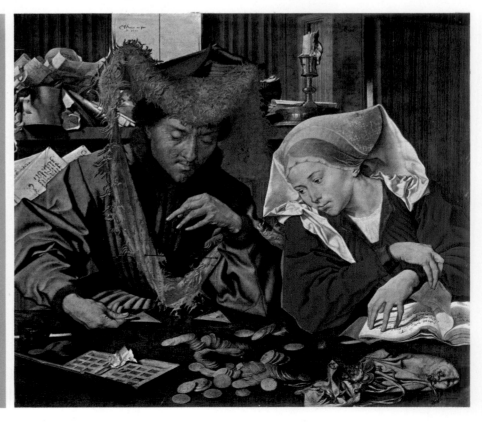

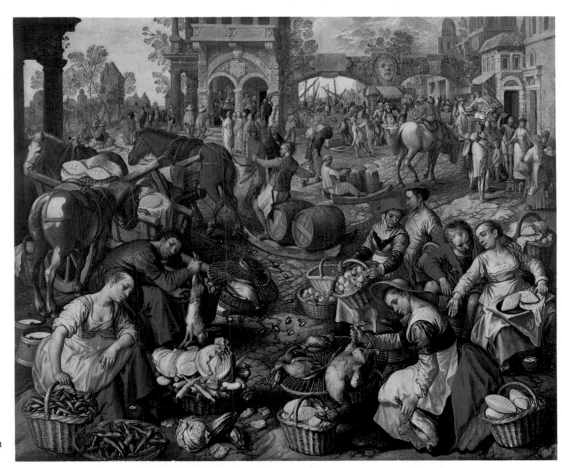

Beukelaer: *Market Day*,
144·5 × 199cm, mid-16th
century

lovers in the countryside, of picnics, of hunting. These are subjects from ordinary life, but idealized, rarified and made intensely poetic by the melancholy poetry of Giorgione and his school. Walter Pater, who praised Giorgione for painting 'morsels of actual life, conversation or music or play, but refined upon or idealized, till they come to seem like glimpses of life from afar', stressed the importance of music:

In these then, the favourite incidents of Giorgione's school, music or the musical incidents in our existence, life itself is conceived as a sort of listening — listening to music, to the reading of Bandello's novels, to the sound of water, to time as it flies.

It is the wistful notes of the flute, or the lute's moody power, that gives many of these Venetian paintings a quality of psychological drama. The divisions between everyday and pastoral life, between depictions of social group and the portrait of the individual, are not always clear.

The works of Titian and Veronese are rich in minor incidents and detail, and a shift of interest to the secondary aspects of a subject, where the artist might display his imaginative powers, was characteristic of Mannerism. Paolo Giovio, writing in 1527, praised Dosso Dossi for his skill in the 'oddments' of art:

The graceful mind of the Ferrarese Dosso was shown not only in normal works but also above all in those that are called 'oddments' (parerga). In pursuing charming little diversions in his paintings as a labour of love, Dosso brought before one's eyes sharp crags, thick groves, dark shores of rivers, flourishing rural scenes, busy farmers at work, broad expanses of land and sea, as well as fleets, markets, hunts, and all that sort of spectacle, all done in merry, free and festive style.

In the works of Jacopo Bassano the religious subject matter becomes part of a description of rustic life; the foregrounds are crowded with tender country scenes, showing women caring for children, and prominent still-lifes of pots and pans and other domestic utensils.

A parallel development occurs in the work of the sixteenth-century painter, Pieter Aertsen, who, with his pupil Joachim Beuckelaer, introduced into Flemish art in the mid-

Aertsen: *The Dance of the Eggs*, 84 × 127cm, 1557

The point of the Egg Dance, an ancient custom popular in Holland in the sixteenth and seventeenth centuries, was to avoid treading on the eggs. Aertsen sets the scene in a brothel and probably intended the dance as a symbol of folly and lust; a contemporary print of an egg dance is inscribed: The fools dance has no measure/for each follows his lust wherever it leads/Whoever can keep this measure and rule in everything/Can escape this dance of the fools. The old bagpiper looks anxiously at the raised beer-pot, a motive that was to be used by Bruegel. The graceful Italianate poses of Aertsen's figures, however, are far removed from Bruegel's earthy vitality.

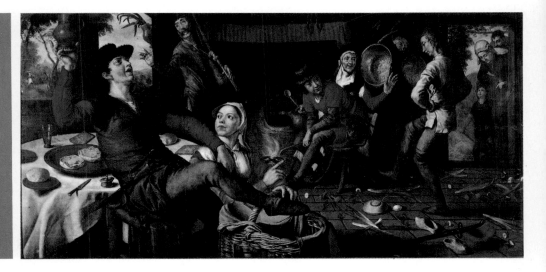

Giorgione/Titian: *Concert Champêtre*, 110 × 138cm, c.1510

It is unlikely that this improbable subject — a pair of clothed men with two nude women in a landscape — is a scene from Renaissance life, although it was so interpreted in the nineteenth century. It has been convincingly suggested that the two women are nymphs, invisible to the men, who remain profoundly self-absorbed. In Venetian art the boundaries between everyday life and pastoral life are not always clear cut. Other artists — Romanino, Savoldo, Niccolo dell'Abbate — painted more worldly scenes of musical gatherings and picnics, while retaining some of Giorgione's wistful poetry. The sense of things unsaid, the romantic colours, the atmosphere of evocative reverie, and the haunting relationship between music-playing figures and landscape, forma prelude to the fragile poetry of Watteau. The painting has been attributed both to Giorgione and to Titian.

17

strings of sausages, pigs' heads, poultry, cabbages, brilliantly coloured and lushly painted. In the background, revealing a Mannerist love of virtuoso spatial design, he often introduced a tiny religious scene. Many of Aertsen's pictures are, however, without traditional subjects. His cooks and peasants stand before us with a quiet dignity, their expressions withdrawn, sometimes melancholic; his young women are often glowingly beautiful, with a robust grace that seems to assert their right to be painted on the heroic scale and with the deep seriousness hitherto reserved for religious painting. The humanist scholar, Hadrianus Junius, likened Aertsen to Pliny's Peiraikos, thus illuminating how the avid reading of ancient writings on art encouraged the rise of specialized categories of subject matter.

In the late 1550s, Pieter Bruegel, drawing on a sixteenth-century German tradition of graphic art, began to paint the pleasures and festivities of the peasant. It is the sheer vitality and energy of human instincts and passions that Bruegel

sixteenth century a new type of subject – scenes from the life of the peasants, kitchens, markets, butchers' shops with gutted animals. Aertsen piled high the foreground of his paintings with a vast profusion of still-life detail, such as

ABOVE LEFT **Bruegel**: *The Peasant Wedding Feast* (detail)

Bruegel: *The Peasant Wedding Feast*

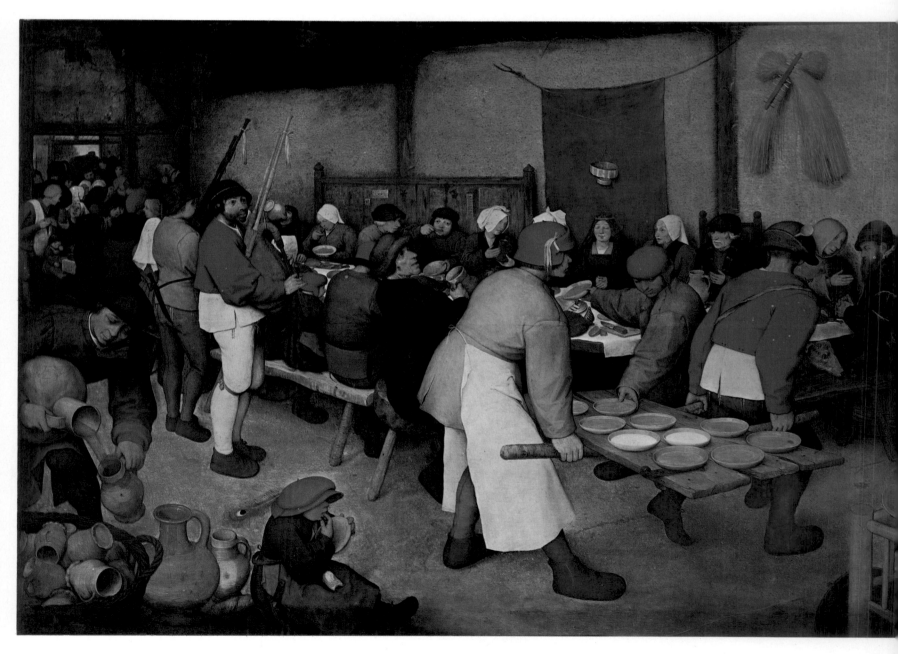

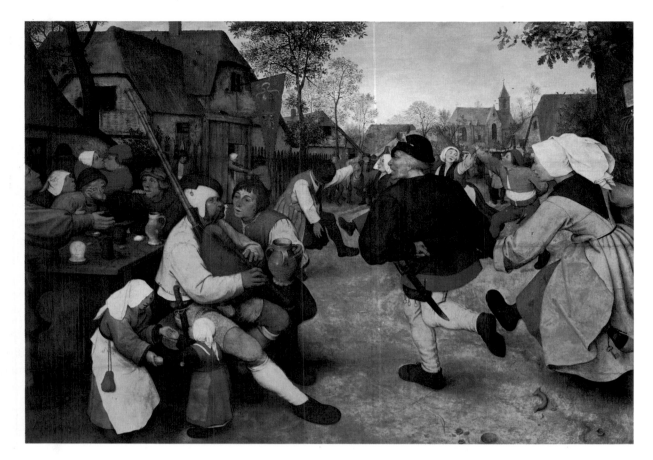

Bruegel: *The Peasant Dance*

observes in these works; his figure style is monumental, almost sculptural, although lacking Aertsen's stylish references to Michelangelo. Bruegel's world has neither the tenderness nor the charm of Aertsen's; the peasants' bodies are heavy, the silhouettes expressively ugly, the gestures coarse and clumsy. Yet, in the *Peasant Wedding Feast*, before the stored corn, a reminder of the labour of the year, they

Bruegel: *The Peasant Wedding Feast*, 114 × 163cm, c.1567–8
Bruegel: *The Peasant Dance*, 114 × 164cm, c.1567–8

In these two works Bruegel's monumental figure style and convincing organization of a crowded space endow peasant festivities with the impressive grandeur normally reserved for biblical and mythological scenes. The scene in the *Wedding Feast* takes place at harvest time; the last sheaf hangs before the stored grain on the right. A crowd in the background tries to get in, and our eye is skilfully led along the line of the table to the food carriers, taking in the comic contrast between the anguished hunger of the bagpiper, who watches the food go past and the total absorption of the more fortunate child, swamped by its hat, in the foreground. A chain of gestures then leads the eye back to where the smug bride sits before a makeshift cloth of honour. The absence of the groom is puzzling; he may, however, be the young man passing rijstpap from the unhinged door which acts as a tray. The bridegroom was not invited to feast with the guests but waited on them.

In *The Peasant Dance*, an elderly man pulls forward his companion to join the festivities. A young peasant brings a large pitcher to the bagpiper, and two children imitate their elders. In both paintings the figures have a remarkable individuality and there is a wealth of humour, wit and observation in the strongly characterized heads. Bruegel does not include the bestial behaviour shown in contemporary prints of such subjects; his attitude seems to have been more tolerant and amused.

snatch greedily at their scarce and earthy pleasures. Each figure is intensely individual; there is a comic contrast of kinds of greed, as found in the extraordinarily expressive face of the bagpiper whose eyes light up at the sight of the food, the absorbed finger-licking child in the foreground, and the smug and complacent bride. In the *Peasant Dance* there is no conventional gaiety of expression; the sonorous rhythms of the dance have a primitive urgency, and the peasants kiss and fight coarsely and blankly. Bruegel's peasant stands before us for humanity, and the scale of his vision parallels the comic grandeur of Rabelais' Panurge and Shakespeare's Falstaff. Bruegel's art is deeply rooted in observation, and he is amused by and tolerant towards man's struggles and desires.

By the end of the sixteenth century secular subjects had become established as a minor branch of painting. In the years around 1600 this slow development culminated in a dramatic flowering; scenes of ordinary life were liberated from their role as mere decorations or overtly moral teaching. All over Europe a reaction against the artificialities of

Bruegel: *The Peasant Wedding Feast* (detail)

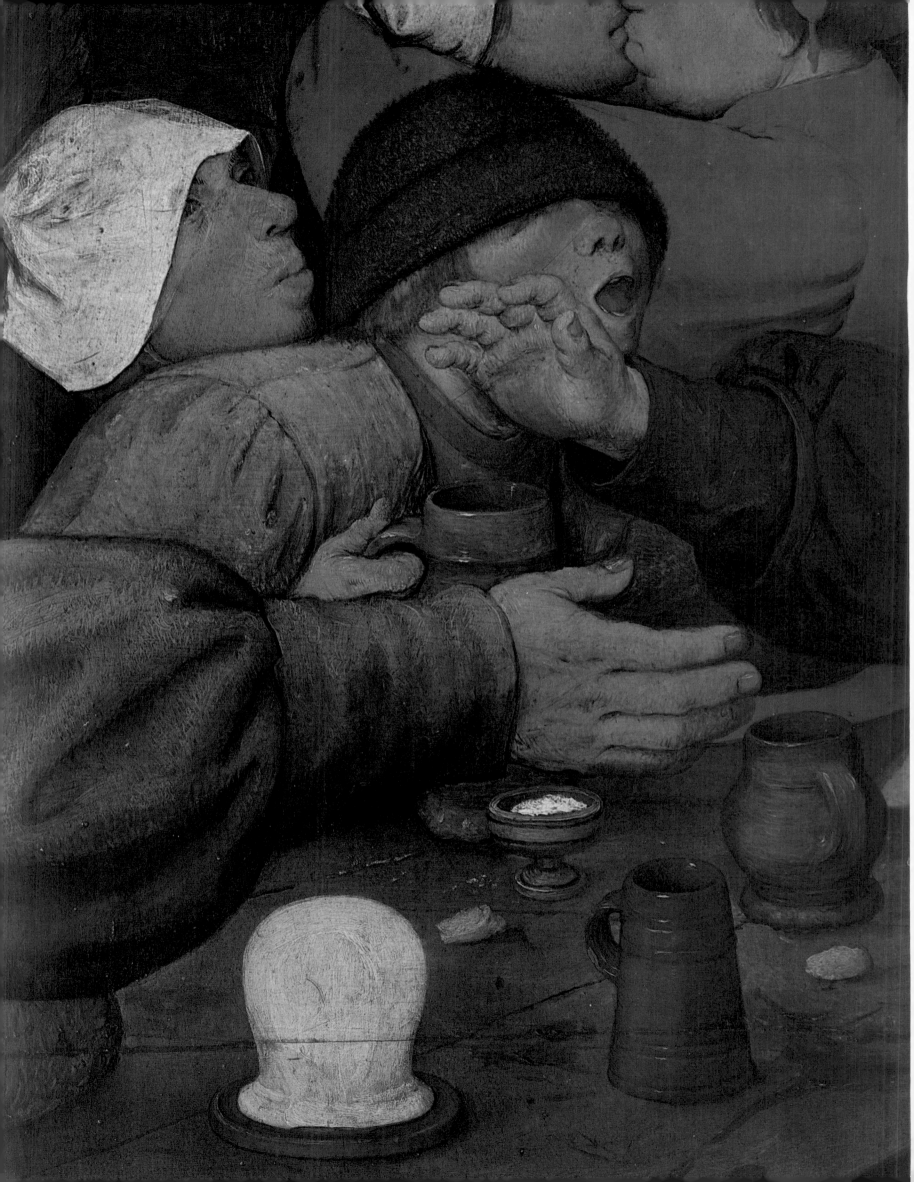

Caravaggio:
*Boy with a
Basket of Fruit,*
70 × 67cm,
c.1594

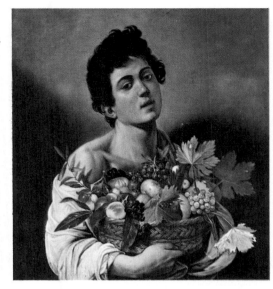

Mannerism led to a renewal of interest in nature and encouraged artists to choose themes from the world around them, landscape, still-life, and everyday activity.

In Italy, such exclusive specialization was left for the foreigners. Nonetheless, even Annibale Carracci, who re-established the grand manner of Raphael and Michelangelo, sought relaxation in drawings and paintings that reveal a sympathetic observation of the ordinary life of low-class types; his home town, Bologna, became a centre for this kind of subject. A trace of the Giorgionesque tradition, of lovers and musical gatherings presented with an exquisite elegance and grace, is still evident in the early works of Caravaggio.

Yet Caravaggio's name has become synonymous with a liberating and revolutionary naturalism, and it is true that the aesthetic and spiritual revolution that he brought about opened up new areas of subject-matter. His religious scenes are unheroic, the surroundings squalid, and the humble protagonists, like the coarse peasants, with weather-beaten features and wrinkled feet, are a new and deeply moving presentation of the poor in great art. We hear of Caravaggio calling in a gypsy from the street to paint her as a fortune teller and goading his contemporaries with provocative remarks designed to overthrow the whole tradition of a hierarchy of values — he is reported to have said that 'it required as much skill to paint a good picture of flowers as one of figures.' Caravaggio, however, remained essentially within the great tradition of biblical and history painting, and the concept of naturalism must be used with some caution when one looks at his early paintings of secular subjects. These show half-length figures of boys with baskets of fruit, lute players, musical concerts, fortune tellers. The still-life details are painted with crystalline clarity, in an attempt, new in Italian art, to capture the bloom on the skin of a peach, the highlights on grapes, worm-eaten leaves, and the texture of wood grain and glass. Yet the total effect is not naturalistic; there is no attempt to describe a setting — the figures are posed before a neutral background — and the young men have a glamour and elegance, a narcissistic charm, far removed from ordinary experience. Their hair is beautifully dressed and arranged, their dress dazzling, and their shoulders emerge erotically from startlingly white drapery. Such works were not intended to capture a moment of real life, but to appeal to a sophisticated and decadent taste. Caravaggio's followers popularized throughout Europe these kinds of fanciful scenes of card sharpers, musical concerts, fortune telling, in which the participants have the raffish charm of low-life romance.

Yet at the same time, perhaps liberated by Caravaggio's aesthetic revolution, Northern artists were introducing into art a whole new range of material. These Northern artists, working in Rome in the 1620s and 1630s, were led by the Haarlem painter, Pieter van Laer, who was nicknamed *bamboccio*, because he was humpbacked; until late in the nineteenth century the term *bambocciate* became synonymous with the kind of low-life subject that he and his followers established. The academic critic, Passeri, who despised such vulgar subjects, nonetheless praised van Laer for the unadorned truth of his paintings; he wrote that van Laer had opened a window on to life and painted what he saw without any alteration. The world that van Laer shows us is the street life of Rome and the Campagna — not the vast storehouse of classical antiquities recorded by earlier Northern artists, but those picturesque corners where men play cards before crumbling walls with broken columns beside them, and lines of washing and flowerpots are hung across vast remnants of Roman masonry. Van Laer's world is neither caricatured nor sentimentalized, though it is

Jan Both: *A View on the Tiber, near the Ripa Grande, Rome,* 42·1 × 55cm, c.1641

Both, one of the second generation of Italianizing Dutch landscape painters, arrived in Rome by 1638. By this date Pieter van Laer had made popular a new kind of subject matter — the out-of-door, everyday life of the common people of Rome. This early painting by Both suggests van Laer's influence in both style and subject. This view of the Ripa Grande is partly fanciful, and the picture was probably painted either in Rome, or shortly after the artist's return to Utrecht in 1641.

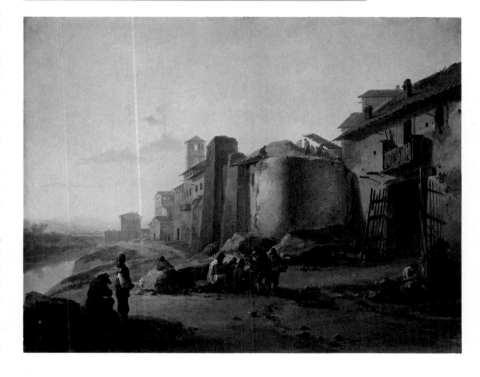

OPPOSITE **Bruegel:** *The Peasant Dance* (detail)

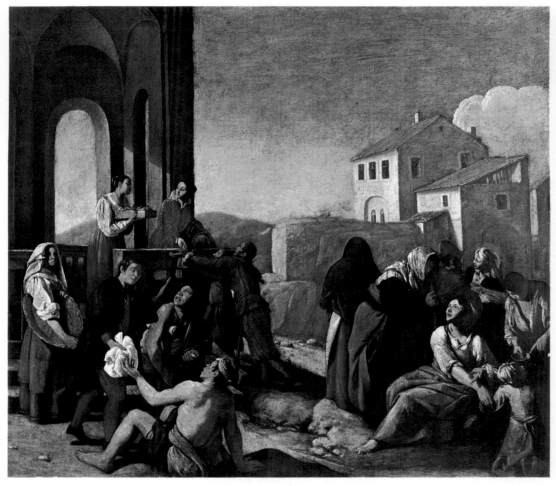

Falcone: *The Charity of St Lucy*, 73 × 84cm, c.1640

OPPOSITE **Murillo:** *The Fruit Eaters*, 145 × 105cm, 17th century

perhaps idealized; it is peopled by a busy and contented peasantry, involved in their daily work and recreations. The paintings are small in scale, and this together with the reassuring mood of stability ensured their popularity; their success was resented by academic artists, and Salvator Rosa, who had himself begun his career as a painter of *bambocciate*, expressed some of their mood of bitter resentment. In his satire, *Painting,* he castigated those patrons who denied alms to the poor while paying large sums for paintings of them – 'What they abhor in real life they like to see in a picture' – and in *Poetry* he described the social evils that should be

the true subjects of the artist and that he should speak of with passion and fearlessness:

Tune your lyres to the weeping and the shrieks
Of so many orphans, widows and beggars.

Rosa was a Neapolitan, and his experience of the evils of Spanish autocracy had perhaps inspired a genuine concern for the downtrodden. In general terms Neapolitan art of the seventeenth century is dark and morbid, often cruel, but occasionally it represents the poor with a startling sincerity and compassion. Aniello Falcone's *The Charity of St Lucy* shows a populace that is poor, crippled, ugly, and

Rubens: *The Flemish Kermesse,* 149 × 261cm, 1630–5

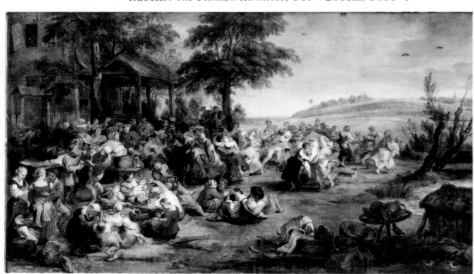

Le Nain: *Peasant Family,* 97 × 122cm, 1640s

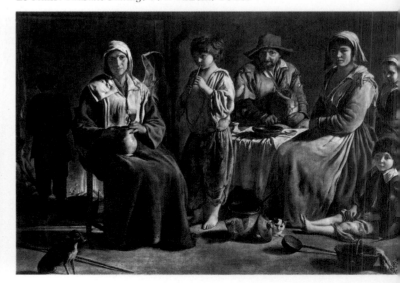

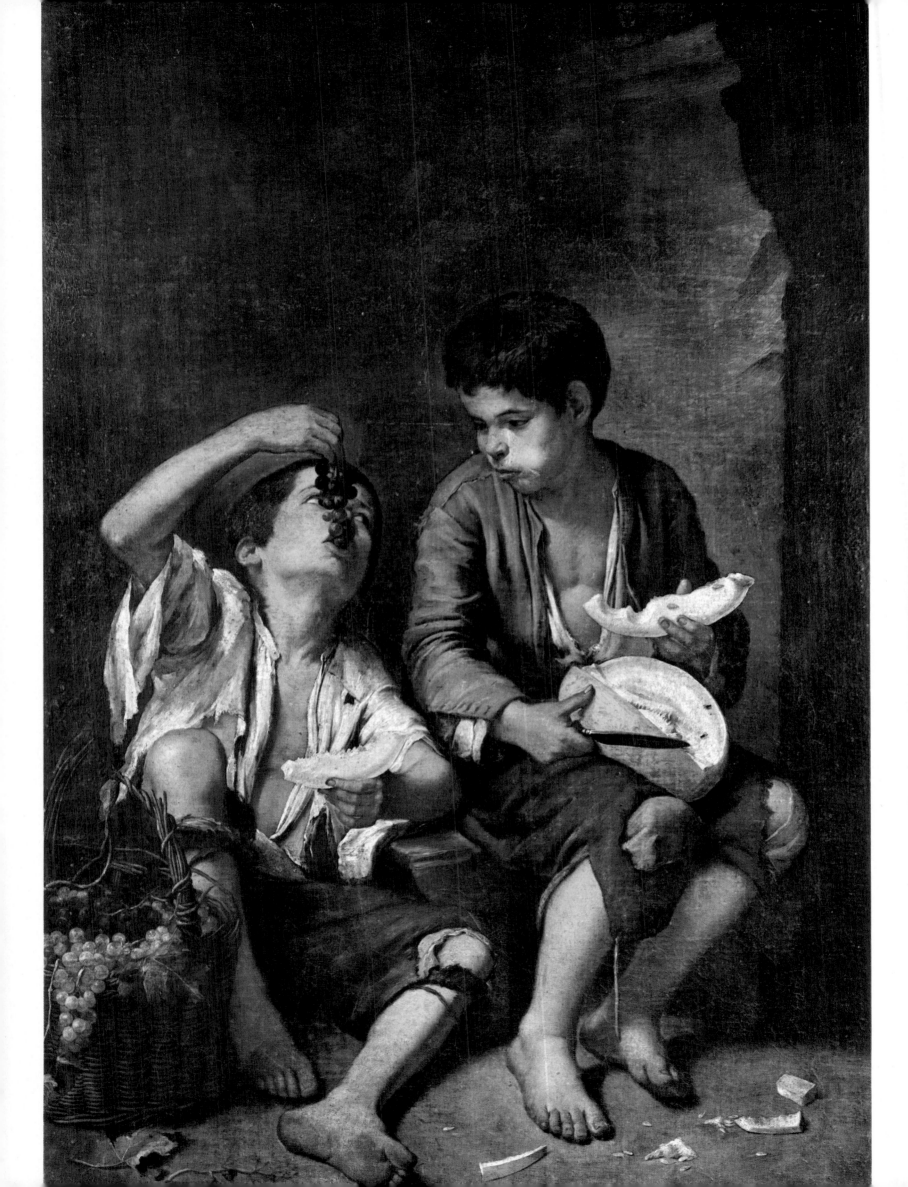

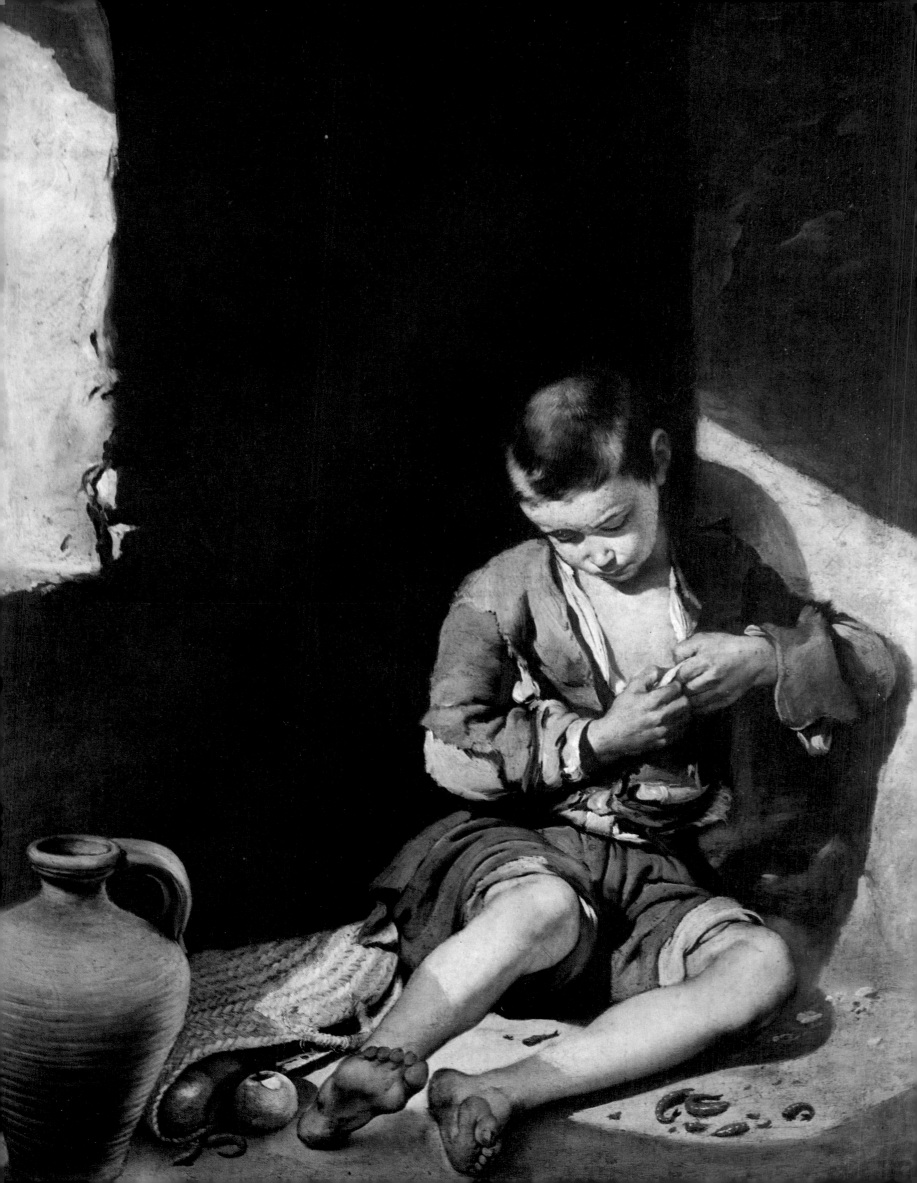

Right **Sweerts:** *The Tavern*, 100×95cm, c.1658

Michael Sweerts, a Flemish artist, spent about ten years in Rome (c.1646–54/6), where he began to paint scenes set in the streets of contemporary Rome influenced by van Laer. Yet, when he is compared with other *Bamboccianti*, his paintings are more tender and compassionate; the compositions are static and have a quiet dignity that reminds us of Le Nain and Falcone. *The Tavern*, which contrasts sharply with the rowdy scenes of Adriaen Brouwer, has a curious dead-pan humour; the young men seem to be imitating the attitudes and poses of their elders. Sweert's colour harmonies of violets, greys, light blues and browns are strikingly unusual and his mild light and pure colours at times seem to anticipate Vermeer.

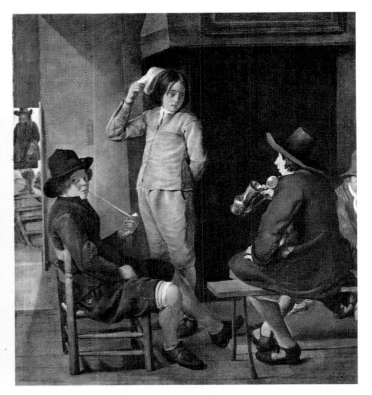

that yet retains some dignity; a tender humanity lights the face of the alms-givers. So direct and objective a rendering may perhaps be paralleled only in Velazquez and Le Nain. The Spanish artist, José de Ribera, worked in Naples; although deeply indebted to Caravaggio he painted what he saw before him far more directly, and his *Boy with a Club-Foot* has an astonishing vigour and human reality. It contrasts sharply with the sentimental and romantic paintings of his compatriot Murillo.

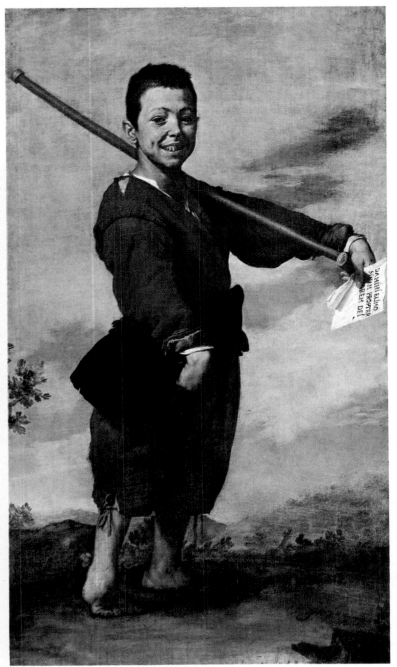

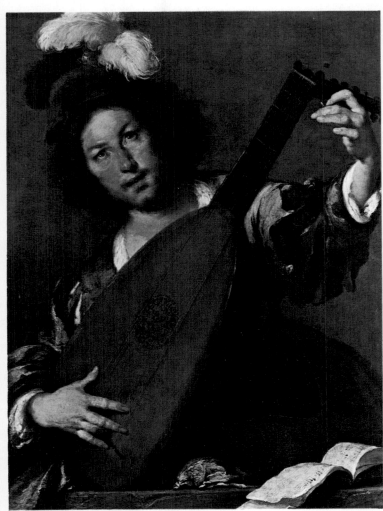

Strozzi: *The Lute Player*, 92 × 76cm, early 17th century

Ribera: *Boy with a Club Foot*, 164 × 92cm, 1642

OPPOSITE **Murillo:** *The Young Beggar*, 137 × 115cm, mid-17th century

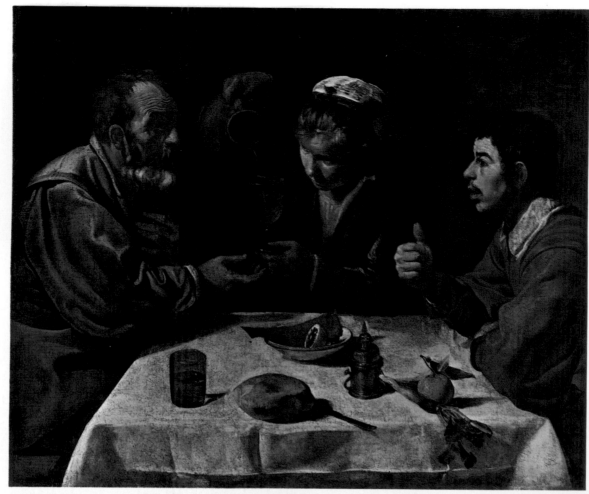

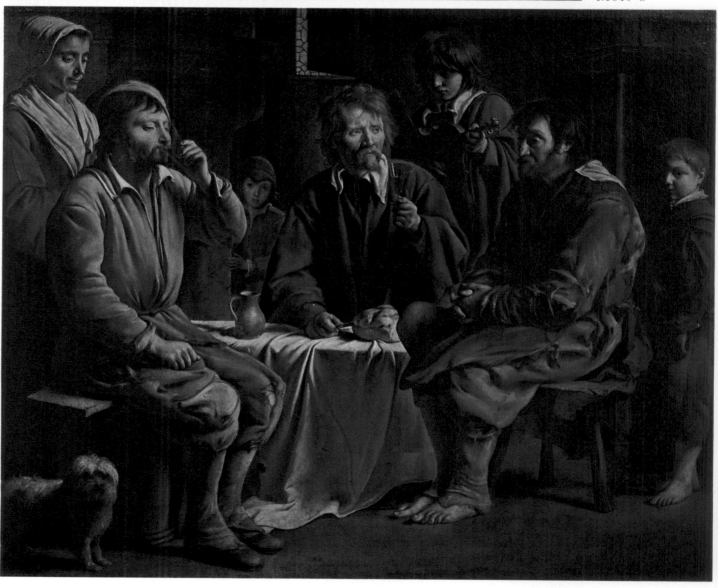

Velazquez: *Peasant Meal*, 96 × 112cm, 1618–19

Le Nain: *Peasants at Supper*, 113 × 159cm, c.1645–8

In France and Spain low-life themes attracted two great artists, whose works have many points in common. The rigidity of academic theory meant that scenes of low life are rarer in French seventeenth-century art than in Dutch or Italian, and the peasant paintings of Louis le Nain are an isolated phenomenon. They owe something to the Dutch *bambloccianti*, yet Le Nain's direct observation of simple people is graver and more solemn. The dignity of humanity is asserted by the classical calm of his compositions; figures and details are carefully grouped in contrasting and balanced poses — a method of composition not unlike Poussin's despite the difference in style and subject-matter. There is a moving quality of remoteness and stillness in Le Nain's presentation; the artist seems to observe his subjects from a distance. The figures are totally self-absorbed, and rarely seem to communicate either with each other or with the spectator; they stare out of the painting with a proud and melancholy resignation.

The paintings of Le Nain share with those of Velazquez a deeply religious quality. In Velazquez' early paintings some simple incident – a boy accepting water from a water carrier, peasants sharing a meal – takes place in a sacramental atmosphere of gravity and silence. Le Nain's many paintings of peasants at supper breathe the same profound significance,

van Ostade: *The Peasant Family*, 43·1 × 36·5cm

instinct, and suffering the effects in drunkenness, defecating, fighting and urinating. In Antwerp Adriaen Brouwer began to specialize in a kind of smoky tavern scene, of extreme squalor, whose ugliness is strangely at odds with his delicate use of colour and refined play of cool and warm tones that subtly create space and atmosphere. In the early works of his Dutch follower, Adriaen van Ostade, the peasants are caricatured to the point of cruelty; the Flemish David Teniers, however, gave them a more sentimental appeal. It is perhaps exceptionally difficult to understand the purpose of these works. Their subject matter is limited, and they show so little interest in the actual experience of the poor, to which nineteenth-century painting has accustomed us, that it is difficult now to tell whether they laugh at or condemn the extraordinary orgies that they depict. Peasant celebrations certainly provided entertainment for

Brouwer: *The Musicians*, 27 × 20cm

Brouwer: *Quarrelling Peasants Playing Cards*, 26·5 × 34·5cm, early 17th century

and the prominent bread and wine seem symbols of the Eucharist. Compositionally, Velazquez' early scenes of humble people, which were painted before his employment by Philip IV put an end to such low subjects, derived from the tradition of Aertsen and Beuckelaer; yet Velazquez chose only a few objects and painted people and things with the same sober realism. Often the elements of his composition seem unrelated to one another, as though he had studied each part separately and intently, extracting their deepest meaning.

In Flanders low-life subjects were treated with a rough and exuberant rowdiness that is far removed from the dignity and restraint of Velazquez and Le Nain. Heirs to Bruegel, artists paint weddings and kermises; they show the peasants celebrating by indulging every kind of bestial

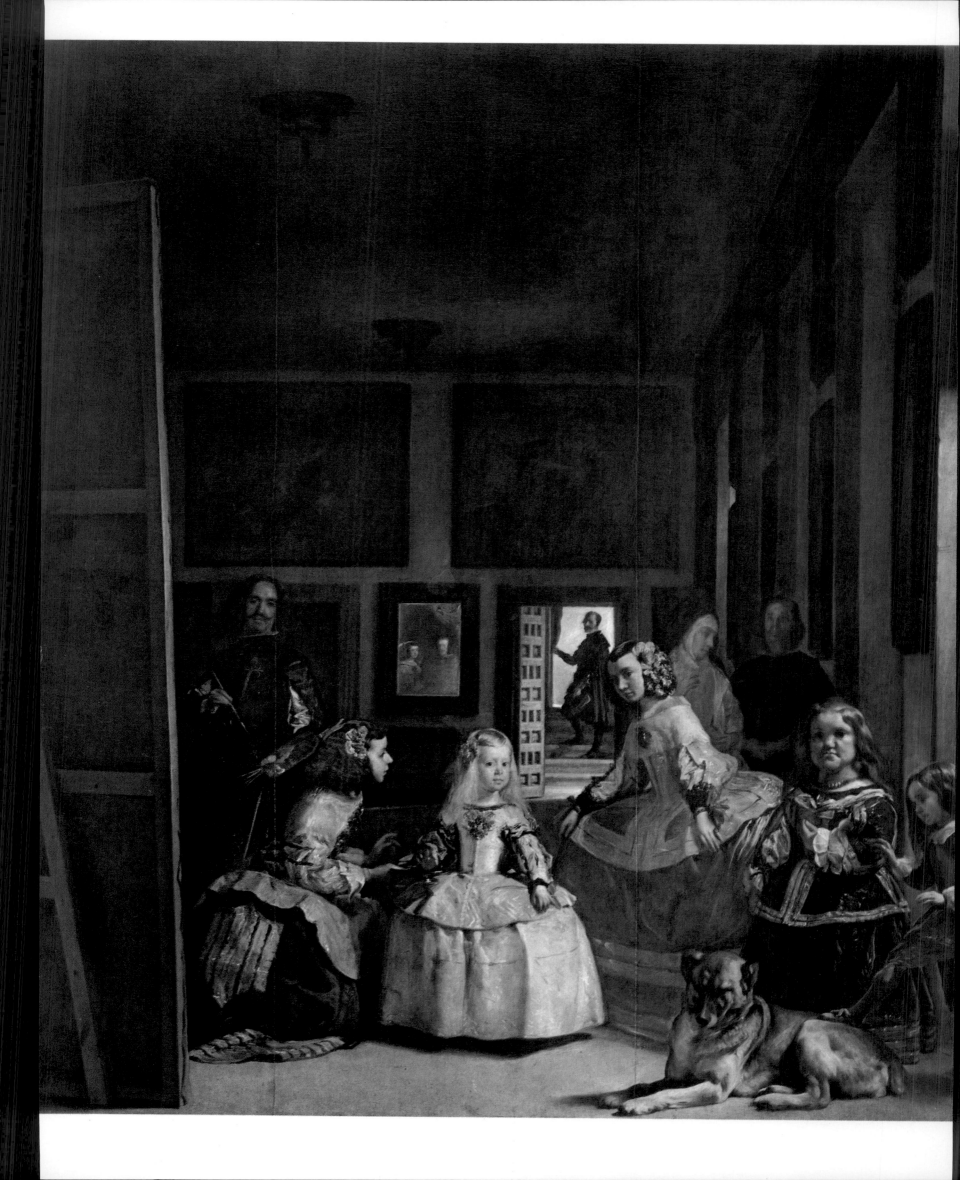

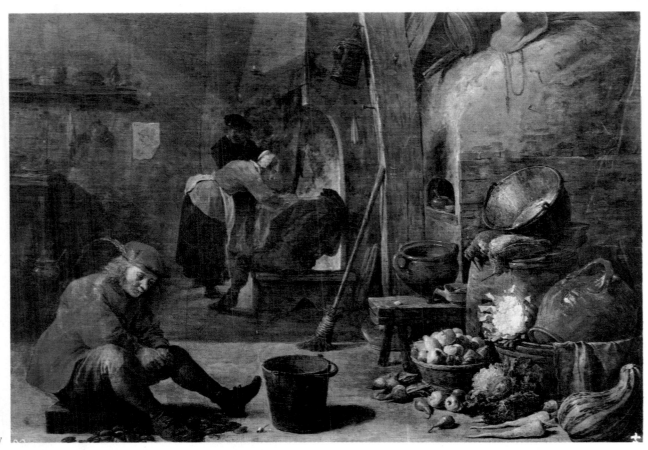

Teniers: *The Kitchen*, 35 × 50cm, mid-17th century

other classes of society, and possibly the paintings were purely comic, an amused look at a festive mood and the gaiety of human indulgence. Yet in some works by Ostade and Brouwer the ugliness is disturbing, and the peasants seem members of a lower species who warn against the abandoning of all Christian constraint.

The most spectacular rise in the popularity of paintings of everyday life occurred in seventeenth-century Holland; from the truce with Spain until well into the eighteenth century a vast quantity of paintings and drawings recorded the life and times of the Dutch burgher. The Dutch Republic was virtually independent from about 1600; it was pre-

dominantly Protestant, and churches were stripped bare of altarpieces and statues of saints. To an unprecedented degree, patronage of the arts rested with the bourgeoisie, and the new power of individual taste may to some extent explain the immense variety of Dutch seventeenth-century art. Artists began to specialize in strikingly limited areas of subject-matter; they no longer worked on commission for great patrons, but offered their works for sale through dealers, thus creating a new and competitive market which encouraged the minor masters to make a reputation in one particular branch of painting.

In the 1620s Haarlem artists were the first to develop a

Rubens: *Peasant Dance*, 73 × 106cm, early 17th century

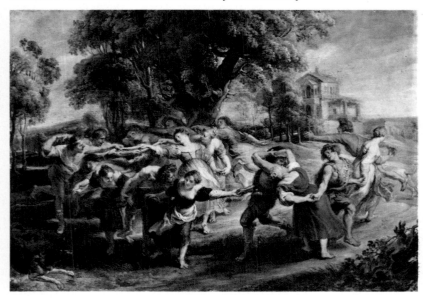

Opposite **Velazquez:** *Las Meninas*, 318 × 276cm, 1656

Velazquez has here attempted to turn the royal portrait into a painting of the daily life of the Spanish court, movingly laying bare the limitations of his own world. Velazquez himself stands at the easel. The princess, whose portrait he is busy on, interrupts the sitting as she turns to greet the king and queen. Their images appear in the mirror on the back wall; they are standing in the position of the real spectator of the picture. The scene has an extraordinary intimacy and charm for a royal portrait, yet its complex mood depends on a touching combination of child-like charm and regality, of tenderness and the stiff formality of Spanish etiquette. The world of the painting seems to reach out to the world of reality, and we identify with the king and queen who pause on the threshold of Velazquez's studio.

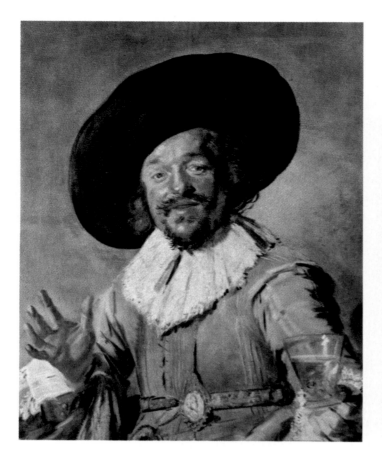

Frans Hals: *The Merry Drinker*, 81 × 66·5cm, c.1628–30

Life-size pictures of flute players, drinkers, gamblers and procuresses were introduced into Dutch art by a group of Utrecht painters who had come under the spell of Caravaggio. Hals' *Merry Drinker* derives from them, but his vigorous portrayal of a fleeting instant far surpasses theirs; the drinker seems to raise his glass to the spectator and to engage him in animated conversation. Hals' brilliant brushwork is free and impulsive, and the bright blonde tonality captures the flickering play of light. Such works are difficult to categorize – it may be a portrait, or part of a set of pictures illustrating the Five Senses, or perhaps an unusually spontaneous transcription of reality. In Hals' work there are not always clear boundaries between one kind of subject and another.

Avercamp: *Winter Landscape* (detail)

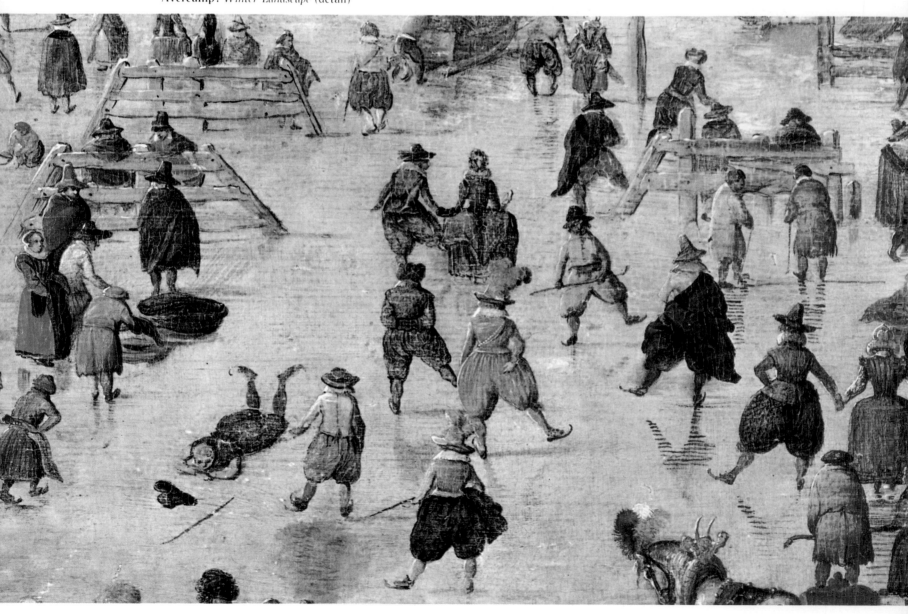

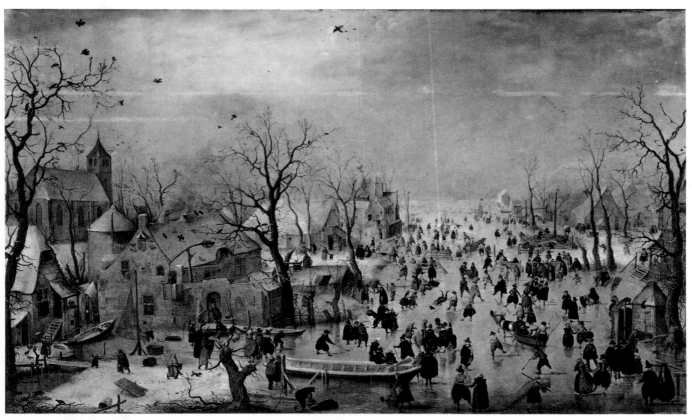

Avercamp: *Winter Landscape*, 77·5 × 132cm, early 17th century

new realism and to describe with passionate enthusiasm every aspect of the world around them. At first sight, these works seem to be a mirror of reality, inspired by the Dutchman's pride in his new material prosperity. The artists record themselves and their country in landscapes, seascapes, still-life, and many scenes of everyday activity — barrack rooms, taverns, inns, brothels, and ordinary bourgeois interiors. Yet realism was not the sole *raison d'être* of these works; many paintings had allegorical meanings and a strong didactic element. The seventeenth-century painter inherited a symbolic language from the art of the Middle Ages, when all human activity had been judged from a moral point of view. What is new is that the symbol is no longer taken from a religious text, but it is fully absorbed into a realistic context, so that today possible layers of meaning are difficult to reconstruct. The artists drew symbols from well-established traditions, from proverbs and aphorisms, and above all from the emblem book, which was particularly popular in the first half of the century. An emblem book is a collection of illustrated sayings that, through a play on double meanings and wittily disguised symbols, make a moral point; the popular Jacob Cats wrote sayings in which small interior scenes illustrate a didactic inscription. The allegorical habit of mind, of searching for symbolic meanings in art and nature, was deeply rooted in the intellectual life of the seventeenth century.

Yet, although Dutch paintings of ordinary life make moral points, they rarely satirize, accuse or judge; the mood is more often tolerant and amused. The painter's themes are in a sense limited and they tend to repeat well-worn types; there are few hints of suffering or poverty. In the early years of the century the merry company and brothel scenes of Willem Buytewech and Dirck Hals held up to ridicule the extravagant dress and luxurious living of a group of young

fops; yet they are painted with amusement, and not with the harsh invective that Hogarth poured on his eighteenth-century rakes. Jan Steen's *Merry Company* paintings remind us more directly of Hogarth, and often they include some

Steen: *The Courtyard of an Inn*, 68 × 54cm. c.1660

31

Hals: *Malle Babbe*, 75 × 58cm, c.1633–5

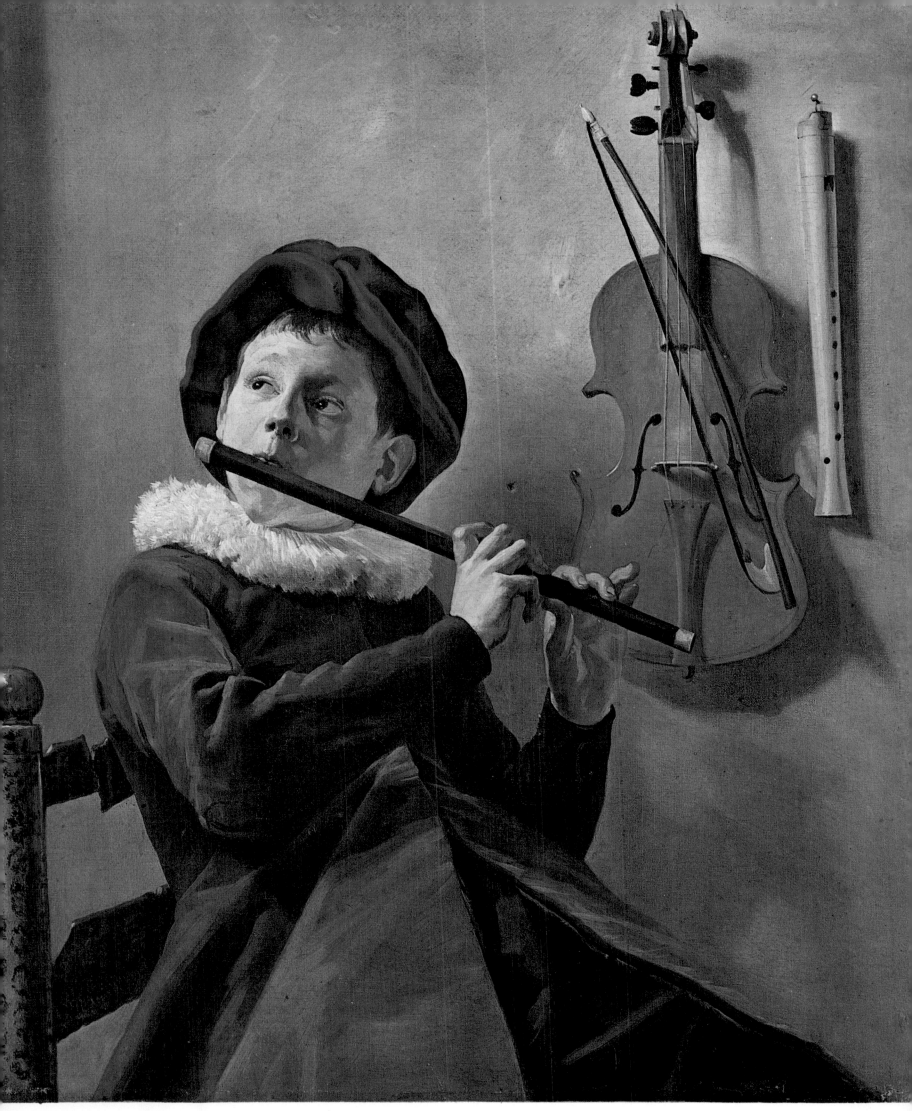

Leyster: *Flute Player,* 73 × 62cm, c.1630

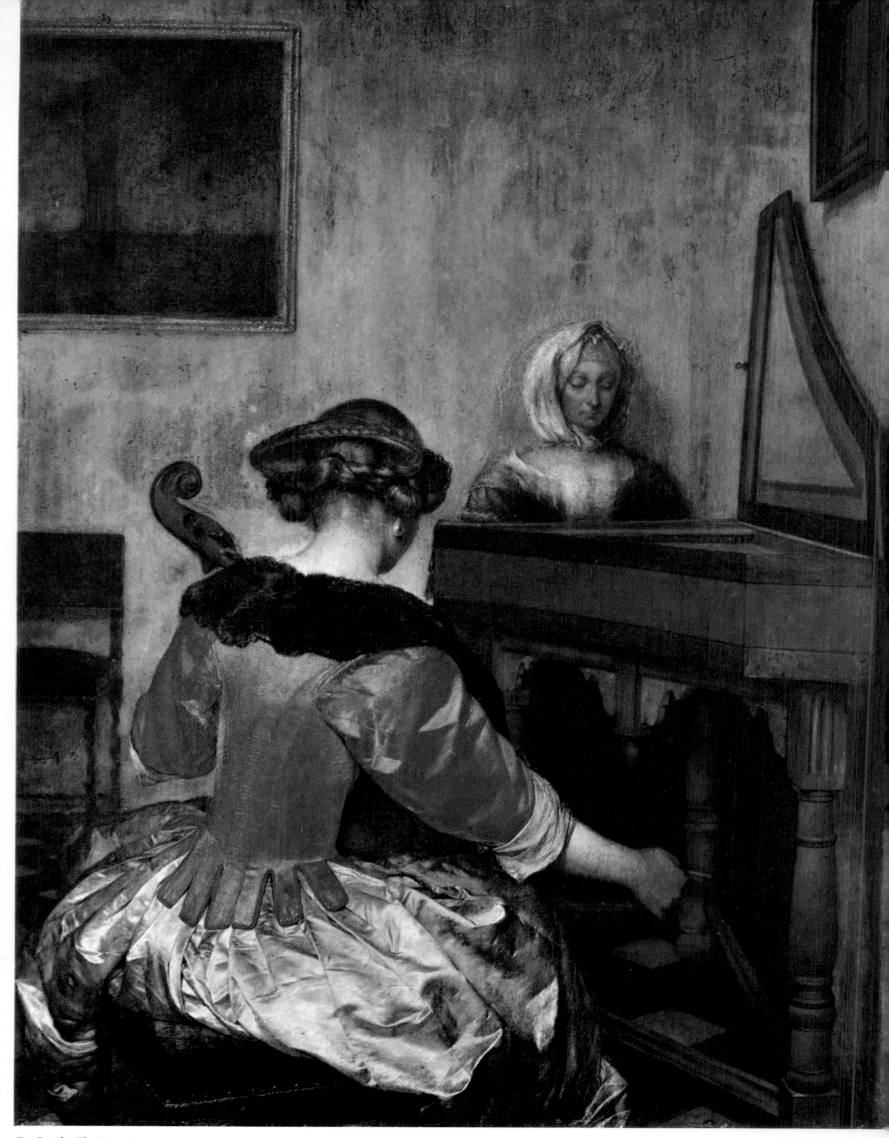

Ter Borch: *The Concert*

moralizing tag such as 'When you lead the sweet life, be prudent', and yet, again, Steen's humour is amiable, and he clearly enjoyed what he painted; his art is rich in theatrical jokes, proverbs and emblems.

The painter's messages were rarely complex: a drunken woman, mocked by her rowdy companions, or an idle servant, asleep amongst the dirty dishes, are held up to ridicule. Scattered rose petals, a man blowing bubbles, the smoke from a pipe remind us that man's days 'are consumed like smoke'; the familiar cry of *memento mori* warns, not too harshly, of the vanity of all worldly pleasures.

The theme of erotic love is interpreted in many ways throughout the century. The harmony of true love is celebrated in the many paintings that show musical parties

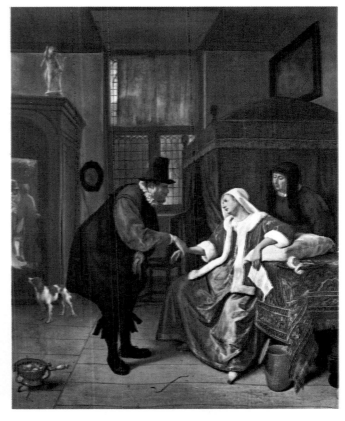

Steen: *The Doctor's Visit,* 61 × 52cm, c.1660–5

Ter Borch: *Brothel Scene,* 71 × 73cm, c. 1654–5
Ter Borch: *Boy Removing Fleas from a Dog,* 35 × 27cm, c. 1655
Ter Borch: *The Concert,* 56 × 44cm, c.1675

The *Brothel Scene* has, until recently, been known as the *Parental Admonition*. It was engraved under this title in the eighteenth century by J. G. Wille, and Goethe, in his novel, *Elective Affinities*, described how the father quietly admonishes his daughter, while the mother looks into her wine to hide her embarrassment. Actually, the soldier holds out a coin, now almost invisible, to the young girl, and the seated woman is a procuress. The misunderstanding bears witness to the delicacy and subtlety of ter Borch's description of psychological nuance. He also excelled in observing the fall of light on satins, furs, velvets and leather, and the minuteness of his handling is reminiscent of fifteenth-century Netherlandish painting. *Boy Removing Fleas* is a direct and exceptionally naturalistic treatment of a simple theme. The *Concert,* a late picture, shows a new fullness of form, clarity of setting and bright daylight that may suggest the influence of Vermeer.

or men and women beside the virginal: an absent lover may be suggested by letter reading or writing, while maps or paintings of ships on the wall evoke the perils of travel. There are many overt and coarse references to physical love, and very many paintings of brothels; men offer women oysters, well-known aphrodisiacs, or copulating dogs make clear the true nature of a transaction in a courtyard. In Jan Steen's *The Doctor's Visit* a doctor takes the pulse of a young and ailing girl. His absurd dress is adapted from a stock character in the *commedia dell'arte,* and such a deliberately theatrical element is strong in many Dutch paintings; the girl is suffering from 'love's sickness' – pregnancy – and the statuette of Cupid and the licentious painting over the bed reinforce the theme. Jan Steen's coarse and robustly humorous treatment of such a subject contrasts sharply with Gerard ter Borch's subtle *Brothel Scene.* A young man,

Ter Borch: *Boy Removing Fleas from a Dog*

Ter Borch: *Brothel Scene*

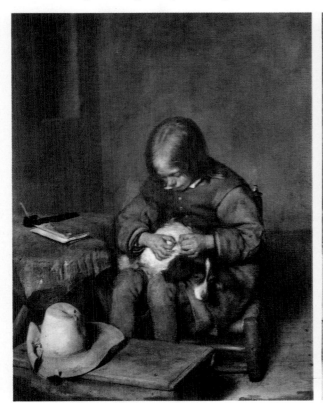

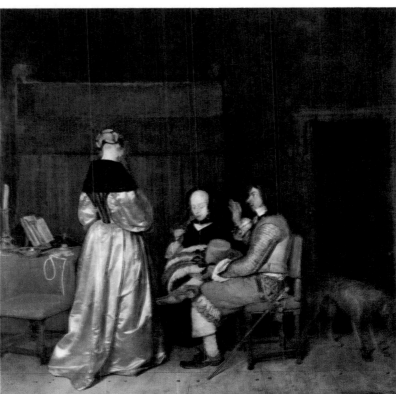

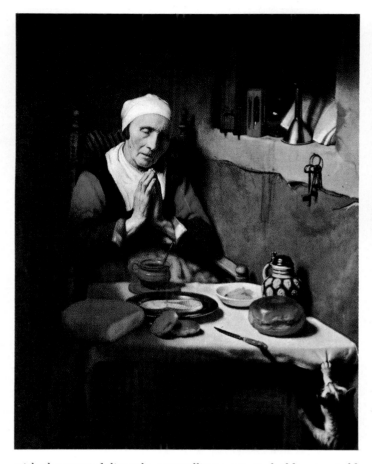

Maes: *An Old Woman Saying Grace*, 134 × 113cm, c.1655

Nicolas Maes had been a pupil of Rembrandt in about 1650; from 1654 to 1660 he painted a number of small pictures of the domestic life of women and children, which retain something of Rembrandt's tenderness, warm colours and use of strong falls of light. Here, the sober piety and simple way of life of the old woman are held up as a pattern of domestic virtue; the presentation is movingly direct and enlivened by the humorous touch of the cat stealing the dinner. Although he tends to point his morals more obviously, Maes' paintings of domestic virtue may have influenced the Delft style of Pieter de Hooch.

with the most delicately compelling gesture, holds up a gold coin to a girl; the girl, arrayed in gleaming satin, stands before her purchaser, and the reticence of her stance is infinitely touching. She turns her back on the spectator, and meekly averts her face and eyes from the young man; the comfort of the surroundings, and the respectability of the unconcerned procuress, underline the pain of the transaction. No other painter presented the prostitute as fragile victim in quite this way: ter Borch excelled in delicate psychological nuance and also in suggesting the beauty of different fabrics and textures.

Yet, although often that of telling stories or of mild moralizing, the main impulse of the Dutch painter was to describe, and it is the beauty of light spilling across a tiled floor, or glowing richly on satin or velvet, or revealing the unexpected beauty of a carafe or pottery jug that makes these works so moving and remarkable. The artists contemplated with satisfaction a bourgeois world of reassuring possessions and the comfort of domestic and social routines. A painting is, after all, not an emblem; it does not have an inscription and does not answer the same needs. As the new secular subject-matter became more established, the clear links with earlier iconographic traditions became less obvious, and in the second half of the century emblem and symbol tend to drop away. Different kinds of subject-matter enjoyed popularity at different periods and were connected with various regional centres. In Utrecht themes derived from Caravaggio were popular. The vital paintings of Frans Hals in Haarlem gave a strong impulse to the category of gay and low-life paintings. In Leiden Gerard Dou dominated a school of *fijnschilders*, or fine painters, whose works are distinguished by their careful craftsmanship and meticulous finish.

After the Treaty of Münster in 1648 the most beautiful scenes of everyday life were painted in Delft. The works of Pieter de Hooch and Jan Vermeer are distinguished by an exceptional clarity and order and by a moving simplicity of motive that assumes a moral significance. Walter Pater wrote in *Imaginary Portraits*:

The nation had learned to content itself with a religion which told little, or not at all, on the outsides of things. But we may fancy that something of the religious spirit had gone, according to the law of the transmutation of forces, into the scrupulous care for cleanliness, into the grave, old world, conservative beauty of Dutch houses, which meant that the life people maintained in them was normally affectionate and pure.

The greatest of Pieter de Hooch's works, painted in Delft from 1654 to c.1660 are those that show the charm of the simple domestic tasks of women and children — peeling

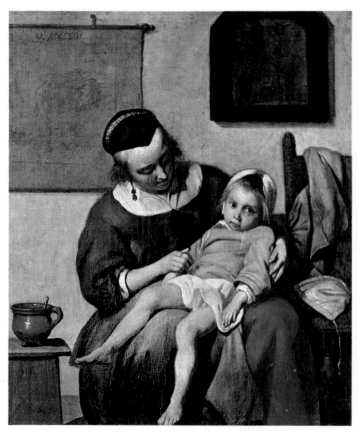

Metsu: *The Sick Child*, 33·2 × 27·2cm, c.1660

apples, fetching food from the pantry, pausing to talk in the doorway. De Hooch's sense of composition is infinitely subtle; often a door or window opens up a vista from one room into another, or into a courtyard or garden, and there is a complex play of movement in and out of space. The figures are held and transfixed in an elaborate arrangement of rectangles; often a distant footfall seems to break into the contemplative silence that surrounds them. The clarity of the design, and the careful rendering, almost brick by brick, of the textures of tiled floor, brick walls, wooden shutters, give a new and deep meaning to the bourgeois virtues of cleanliness and hard work that have produced this well-scrubbed and repeatedly white washed-look.

Vermeer's world is more enclosed and self-contained; he concentrated on the corner of a white-washed room, shut to the activity of the household, furnished with a few carefully chosen and deliberately placed objects. Vermeer's paintings have a strange stillness and silence; the figures are remote

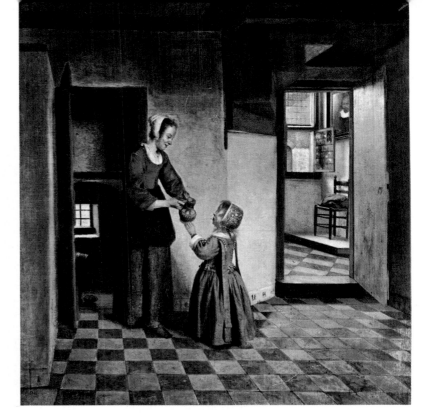

de Hooch: *The Pantry*, 65 × 60·5cm, and detail, c.1658

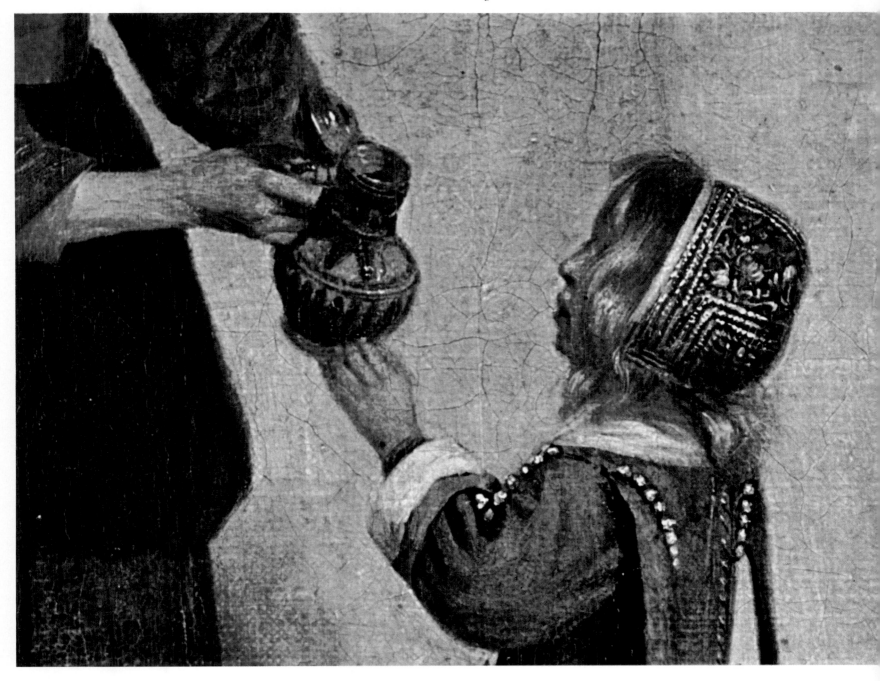

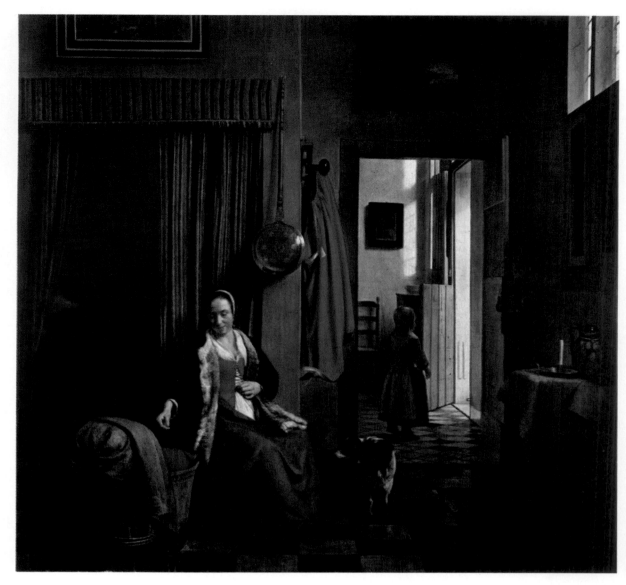

de Hooch: *A Mother beside a Cradle,* 92 × 100cm, c.1659–60

and preoccupied and rarely seem to communicate either with each other or with the spectator. In the 1660s he produced a series of works in which a single female figure dominates a quiet interior; they are moving images of domestic tranquillity, of the modest virtue of women. Their

poetic power depends partly on the beauty of his formal design and on the utter certainty of his perception of space. Horizontals and verticals, light and dark, space and solid, are perfectly balanced, and the placing of each accent seems inevitable and deeply meaningful. The poetic power depends too on the transformation wrought on reality by the effects of light; the clear daylight that floods in through the windows quietly uncovers the simple beauties of the world, encrusting with tiny pinpoints of light and bright strokes of impasto the loaves of bread and the lace-maker's bobbin.

There is no parallel in the rest of Europe to the prosaic humanity of Dutch seventeenth-century art. Elsewhere, the seventeenth century was an age of authority, and the art of the Baroque, dominated by the careers of great artists, put its splendour and magnificence at the service of church and state. The eighteenth century was to be a more sceptical, a more tolerant and more diverse age. The absolute supremacy of any one authority, whether secular or religious, was rejected; reason became the standard of judgement. The ornate and lavish art of the Baroque began to seem oppressive to both patrons and painters; freed from the all-embracing demands of church and state they began to grow

Wouwerman: *The Fortune-Teller at the Fair,* 43 × 57cm, mid-17th century

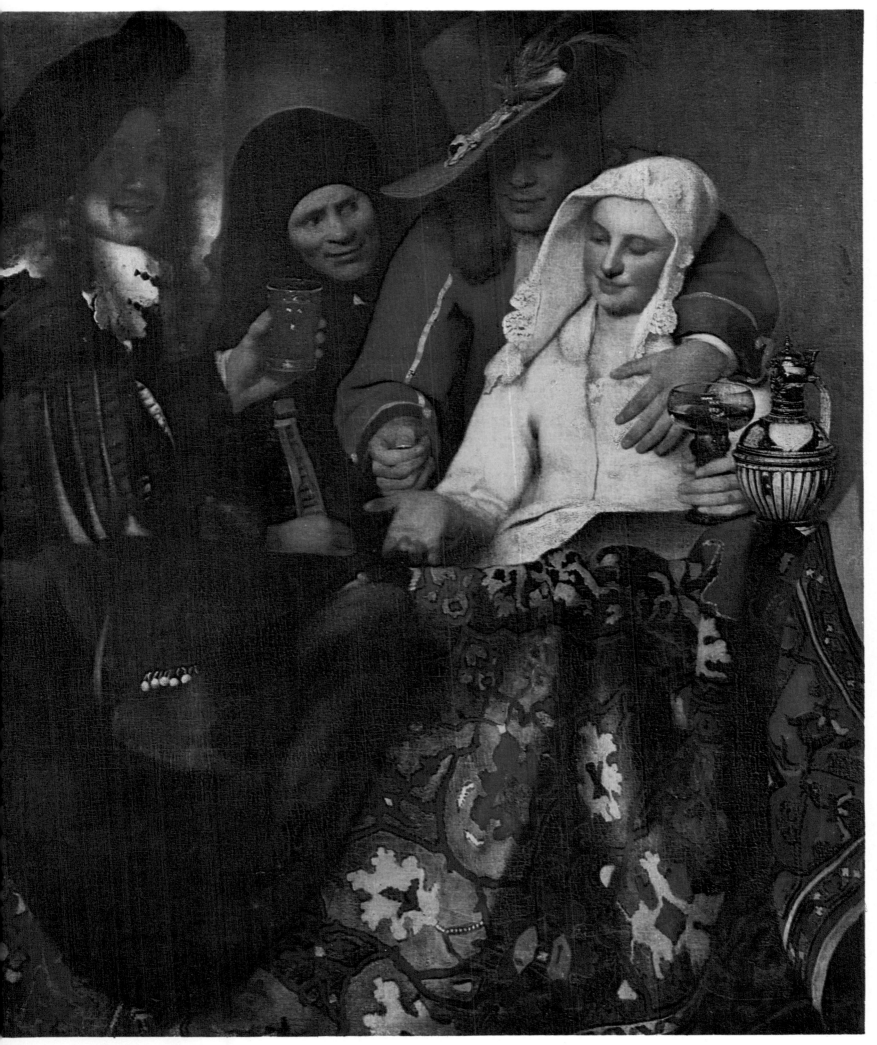

Vermeer: *The Procuress*

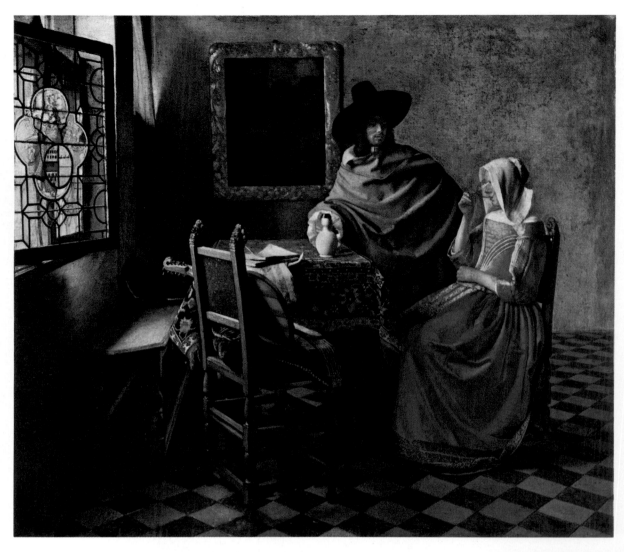

Vermeer: *A Girl
Drinking with a
Gentleman*

BELOW Vermeer:
*Young Woman
Reading a Letter*

Vermeer: *The Procuress*, 143·1 × 130·2cm, 1656
(page 39)
Vermeer: *A Girl Drinking with a Gentleman*,
65 × 77cm, c.1660
Vermeer: *The Kitchen Maid*, 45·5 × 41cm, c.1660
Vermeer: *Young Woman Reading a Letter*,
46·5 × 39cm, c.1665
Vermeer: *The Pearl Necklace*, 55 × 45cm, c.1662–3

Little is known about Vermeer's life. *The Procuress*
shows the influence of those Utrecht painters who had
developed the raffish subjects of Caravaggio. Yet
Vermeer's attempt at rowdiness is not entirely con-
vincing. The still-life has a rich splendour, but the
figures are awkwardly crowded and he appears ill-at-
ease with the human element. The bravo raises his
glass self-consciously, and the warm and human
prostitute lacks erotic subtlety. Later, in *A Girl Drinking
with a Gentleman*, Vermeer attempted the kind of
elegant anecdote developed by ter Borch and Metsu,
but his stiff figures lack their fluency and social ease.
Vermeer's development was towards a greater tran-
quillity; he began to choose simpler motives and to
construct his compositions more clearly. *The Kitchen
Maid* shows a single figure utterly absorbed on a
simple task; the forms are full and vigorous and the
colours, predominantly dazzling yellows and blues, are
warm. Thick bright points of light give a glittering
surface to the crusty bread. The *Young Woman
Reading a Letter* shows his mature style. The tonality
has become cooler, and space is organized with
greater clarity. The gentle presence of the remote and
absorbed figure, the quiet atmosphere of the room,
the careful balance of each formal accent, all create
a sense of harmony and peace.

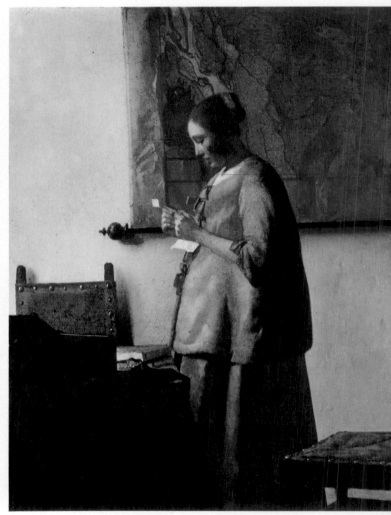

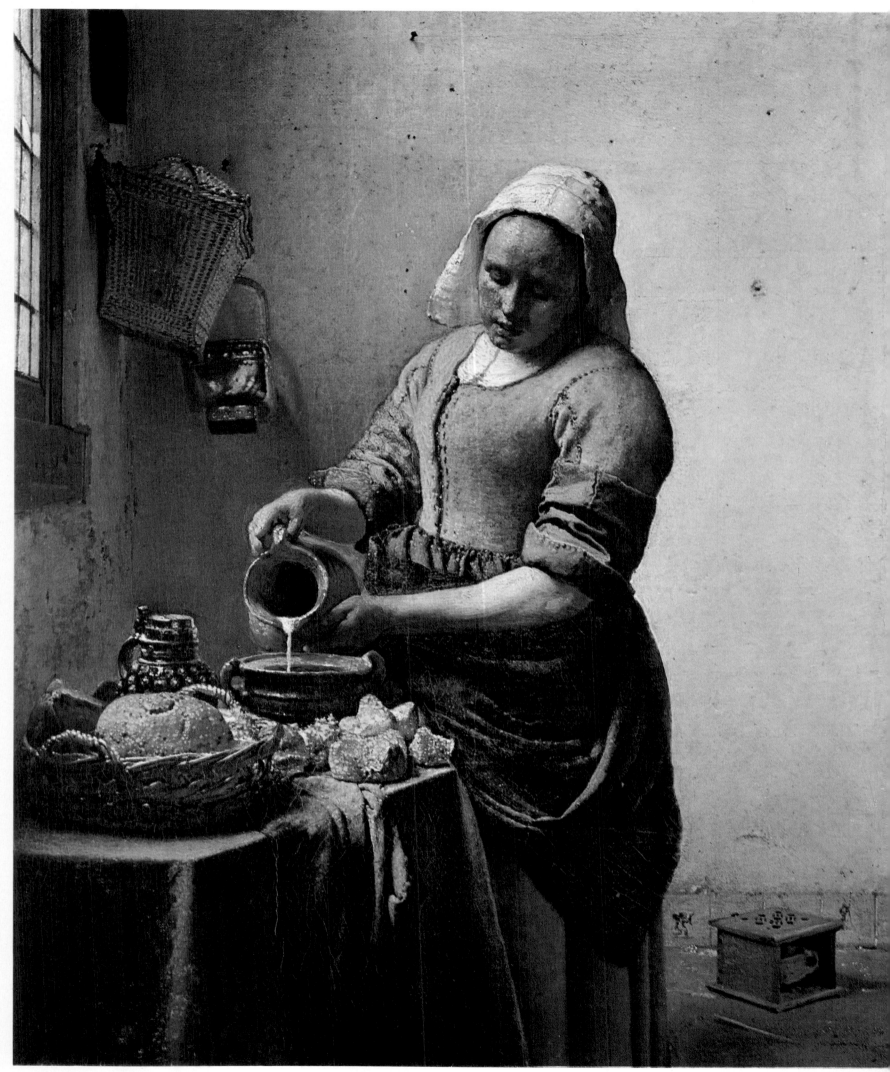

Vermeer: *The Kitchen Maid*

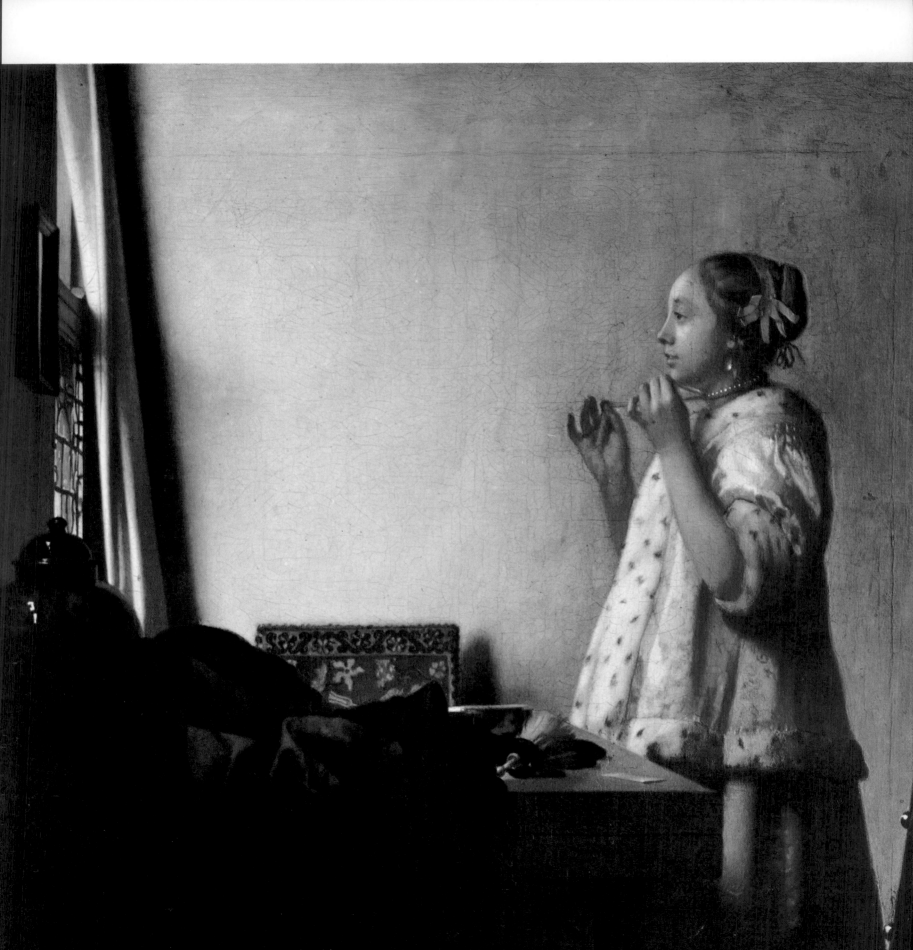

tired of the old themes of gods and goddesses and of the iron-willed heroes of Antiquity. They longed for a more natural atmosphere and for an art that should again show man and his place in society. All over Europe spread a yearning for a descriptive and anecdotal art. Scenes of bourgeois life became popular, and with an increasingly moral stress; the artists did not limit themselves to the illustration of proverb and emblem but attempted to tell an edifying story. The satire of eighteenth-century painters is harsh and often violent; the impulse to improve is stronger than the impulse to describe (as it never was in seventeenth-century Holland), and the artist imposed his own personality and his own vision on his subject-matter.

The artist too became more self-conscious about the seriousness of his aims, and both Hogarth and Greuze showed anger at the contempt in which their kind of subject matter was universally held; Hogarth fought a life-long battle to gain intellectual respect for the dignity of his modern subjects, drawn from the life of his times. There is a close connexion between literature and painting throughout the eighteenth century; Fielding and Hogarth were friends and supported and understood each other; Diderot was an ardent admirer of Greuze, and Goldoni saw in Pietro Longhi 'a man who is looking for the truth'.

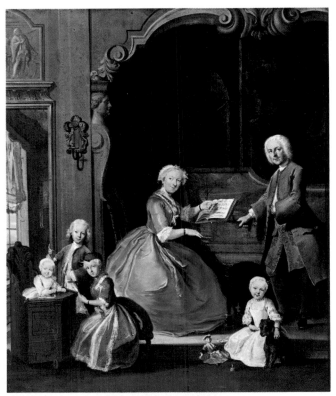

Troost: *Family in an Interior*, 94 × 82·5cm, 1739

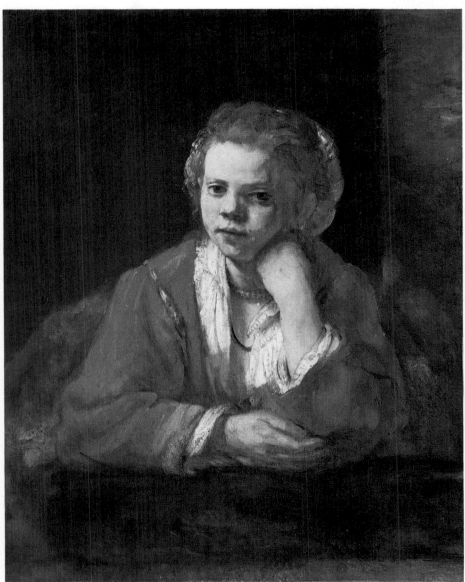

Rembrandt: *A Young Girl at a Window*, 78 × 63cm, 1651

This is one of a group of paintings of Rembrandt's household and members of his family; it is not easy to classify them strictly either as portraits or as studies of everyday life. The compositional device of a figure leaning on a window sill or niche was made popular by Gerard Dou and many of his followers. Rembrandt here avoids their playful illusionism and transforms this ordinary motive into a deep psychological study. The composition has a monumental simplicity and directness; the girl is brought physically close to the spectator, yet she remains withdrawn, and her outward gaze is pensive. Unlike his contemporaries, Rembrandt did not repeat established types of genre subjects but constantly drew what he saw around him. This painting, too, has the immediacy and directness of a study from life.

OPPOSITE **Vermeer**: *The Pearl Necklace*, 55 × 45cm, c.1662–3

Watteau: *The Sign of Gersaint*, 182 × 307cm, 1721

This picture was painted as a sign for the shop, A l'Enseigne du Grand Monarque, owned by Watteau's friend, the dealer Gersaint. It probably formed part of the façade; the steep perspective suggests that one looked up at it, and the girl who steps from the street into the shop leads the spectator into the elegant and grandiose room that seems to open miraculously from the poky surroundings. The description of the men who pack away the portrait of Louis XIV is unusually direct for Watteau, and there is a hint of satire in his portrayal of the kneeling connoisseur. Nonetheless the subject is, still, love; a ballet-like rhythm unites the figures and the group who examine the mirror held out by the serving girl seem absorbed in melancholy reflection.

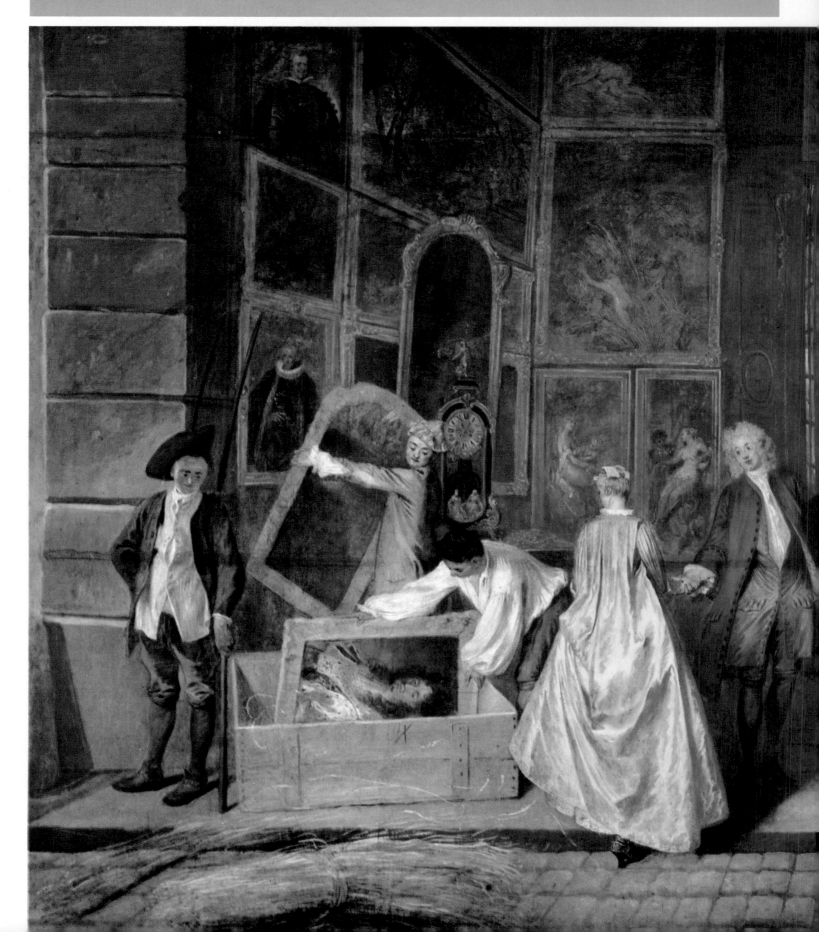

The art of Antoine Watteau — intimate, highly mannered, above all graceful — broke entirely with the severe grandeur of French seventeenth-century painting. Watteau created a new type of picture, the *fête galante*, which shows lovers meeting in parkland or woodland. The poignancy of these works stems from the delicacy with which Watteau apprehends human contacts, and illuminates the meaning of a smile or gesture. Pairs of lovers, isolated by their absorption in one another, and becalmed by music, the food of love, approach each other tentatively, tenderly, sometimes audaciously. The exquisite glamour and ravishing leisure of Watteau's world gave poetic form to the aspirations of his age; he shows a love transformed by dream and fantasy, intensified by the romantic melancholy of the landscape, that will fade before it comes to fruition; as the Goncourt brothers so movingly wrote, 'It is love, but it is poetic love, love which dreams and which thinks, modern love with its longings and its garland of melancholy.' The

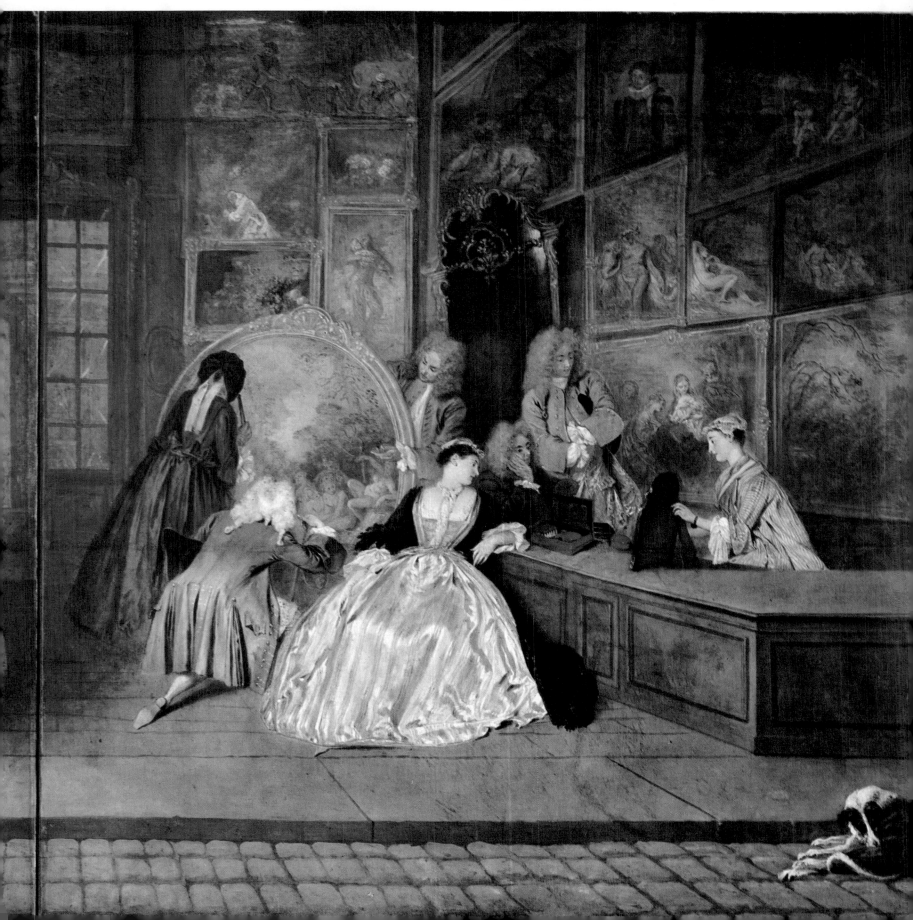

sense of heightened reality that permeates Watteau's imaginary world perhaps explains the deep attraction that the theatre held for him; the traditional characters of the Italian comedy that move through his works — Harlequin the servant, Mezzetin the musician, and Pierrot or Gilles, the clown — are already transformed by the power of art, and his late paintings of actors show him moving towards a more direct and realistic portrayal.

Far removed from the aristocratic dream world of Watteau are the slightly younger Jean-Baptiste-Siméon Chardin's equally revolutionary depictions of the modest life of the petite bourgeoisie. Chardin's works became very popular; for the first time in French art the general public enjoyed plain and straightforward renderings of actions that it might see every day in its own home. Chardin's paintings were first described as 'in the manner of Teniers'; the little Dutch and Flemish masters grew increasingly popular in the more relaxed atmosphere of the 1720s and 1730s. Chardin's mature works show less interest in anecdote and detail; his rendering of most commonplace subjects attains a simple grandeur that is reminiscent of the school of Delft, and many of his motifs derive from Dutch

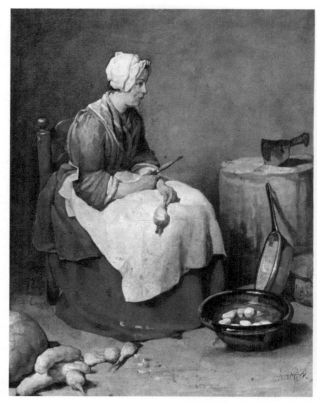

Chardin: *Woman Peeling Turnips.* 46 × 37cm, c.1738

art. His moral sense, his belief in the value of education and of the dignity of the simple daily tasks performed for others, needs no support from emblem or symbol; it is deeply part of the content of his work, and he treats with reverence the atmosphere of decency, honesty and frugality that seems to emanate from his modest bourgeois settings. Chardin refined and purified the elements of reality, and his world is more magical, more reticent and more graceful than de Hooch's; the mothers linger more tenderly over their children, as they say grace or prepare for church; there is a greater sense of a story unfolding. The sense of quiet harmony is dependent not on obvious geometry but on simple pyramidal arrangements and the subtlest rapport between objects in space. His use of paint is more purely pictorial than the illusionism of de Hooch, and it is his wonderful feeling for its texture, for the richness of impasto and the beauty of coloured reflections, that transformed common things into symbols of an ideal world.

In England, the struggle against the dominance of the classical tradition was led by the more verbal and quarrelsome William Hogarth, who did not, as Watteau and Chardin had done, simply ignore the conventions of the late seventeenth century. Hogarth had been trained in the Vanderbank Academy of Art and was steeped in the classical tradition; he found it impossible to reject entirely the doctrine that history painting was the highest form of art. Yet his temperament — self-assertive, quarrelsome, pugnacious — led him to distrust the unthinking admiration of the English connoisseur both for the licentious antics of heathen

LEFT ABOVE **Watteau:** *The Lesson of Love,* 44 × 61cm, early 18th century

LEFT **Watteau:** *The Italian Comedians,* 37 × 48cm, c.1718

OPPOSITE **Chardin:** *The Draughtsman,* 19 × 17cm, c.1738

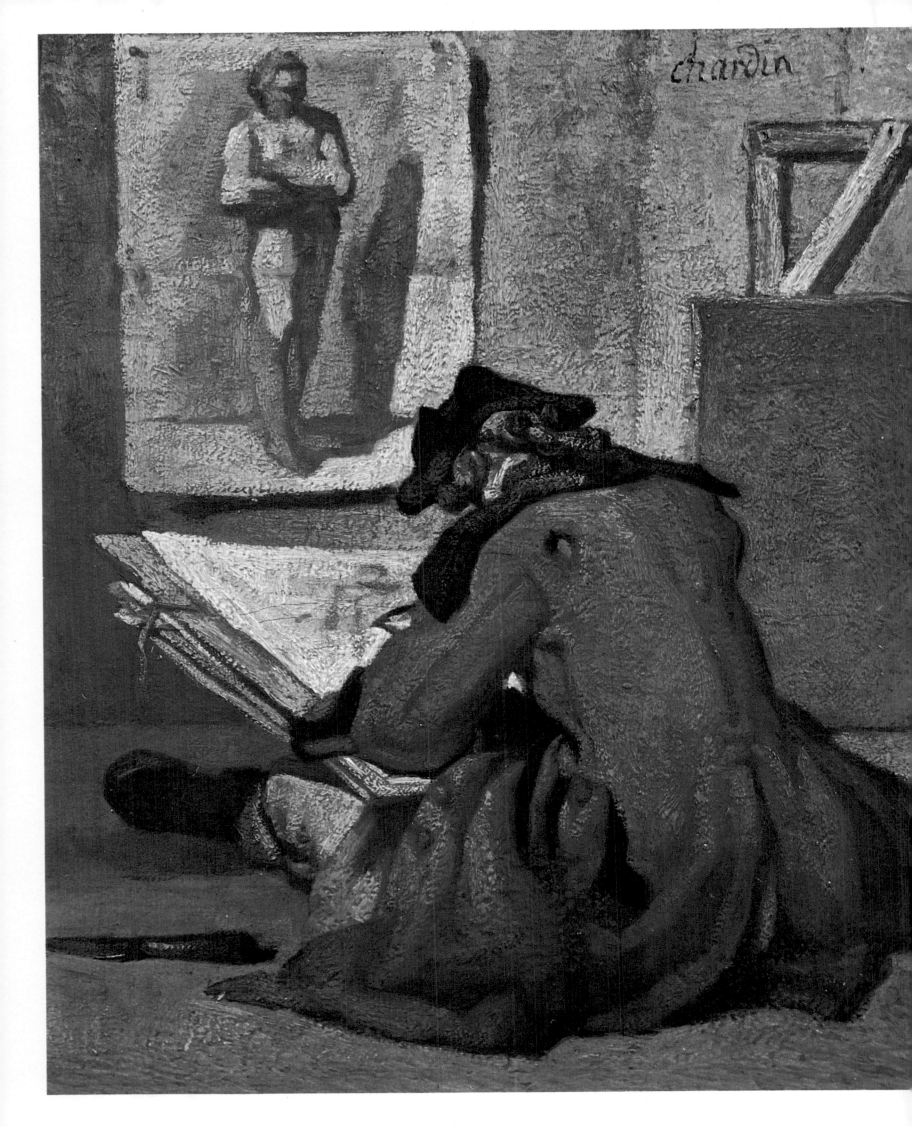

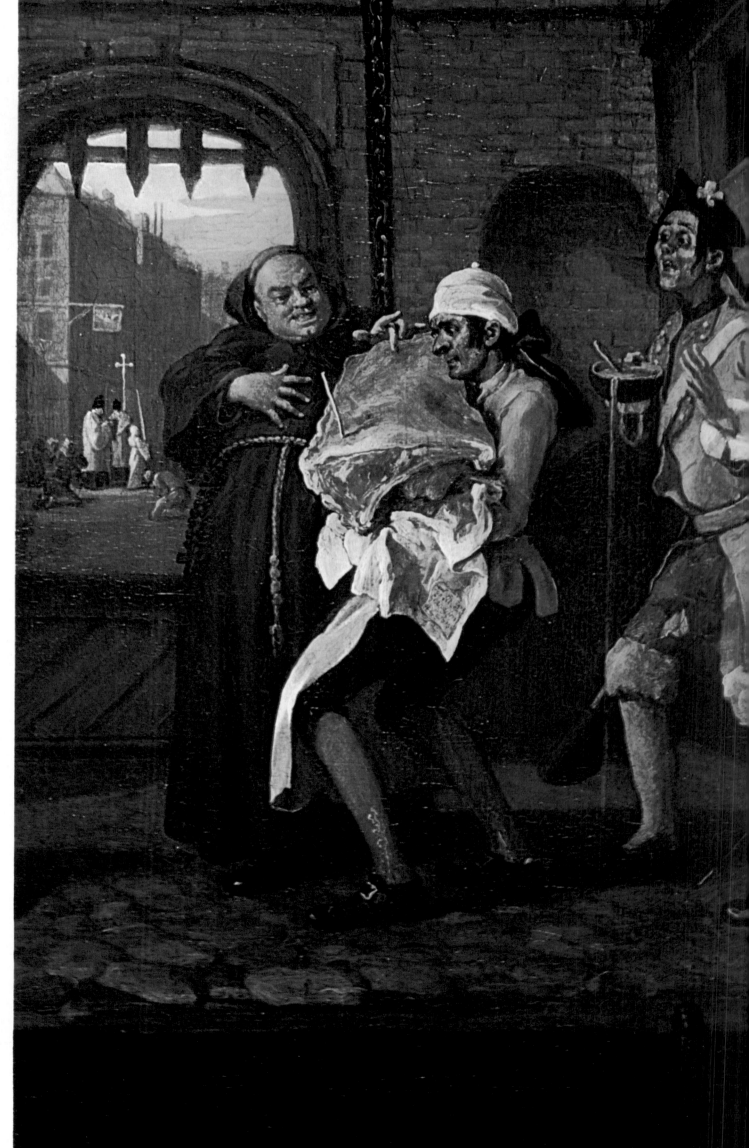

Hogarth: *The Roast Beef of Old England,* 74·5 × 94·5cm, c.1748

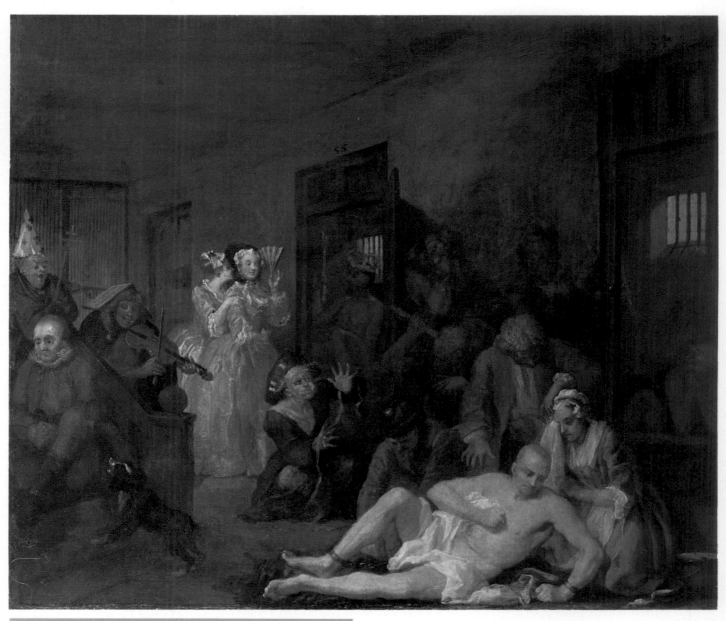

Hogarth: *Scene in a Madhouse*, 62·2 × 75cm, c.1753

This is the last scene of the series *A Rake's Progress*. It depicts the rake, naked and chained, dying in Bedlam, and is a tragic scene showing all types of madmen. On the stairs a pathetic creature sits and gazes, while a grinning pair fiddle and sing. A blind man looks through a paper telescope, an idiot draws a picture of the world on the wall, and in the cells a megalomaniac wears a royal crown and a fanatic cowers on his bed of straw. The fashionably dressed women are onlookers who seek entertainment. The pose of the rake recalls C. G. Cibber's statue of *Melancholy Madness* from the gates of Bedlam. The woman who weeps over the rake is his abandoned lover. The whole group is carefully constructed, and it has been pointed out that it alludes ironically to a Pietà, or group of figures mourning the dead Christ.

everyday life as though they were history paintings. His friend, the novelist Henry Fielding, described him in the preface to *Joseph Andrews* 1742 as 'a comic history painter' and referred to his own work, as a 'comic epic in prose'; at this date the novel, too, was struggling for recognition, and Fielding was claiming a place in the hierarchy below the sublime but above the grotesque. Hogarth himself used the expression, 'modern moral subjects'; he lamented that 'painters and writers never mention in the historical way any intermediate species of subject between the sublime and the grotesque'.

These 'modern moral subjects', *The Harlot's Progress*, *The Rake's Progress*, and *Marriage à la Mode*, produced in the 1730s, are a series of engraved stories that were to teach people the rewards of virtue and the wages of sin. They were immensely popular and satisfied the love of the voyeur for a thrilling and horrifying tale that demonstrated the awful glamour of vice and corruption. The wild career of the rake showed him plunging into the picturesque depths of London vice, gambling, wenching, abandoning his young and pregnant victim, marrying a rich old hag, languishing in the debtor's gaol and finally dying of syphilis in Bedlam. The stories were, moreover, spiced with topical references to

gods and goddesses and for the outmoded ideals and rhetoric of a past era. He wanted to create a type of painting that would be relevant to contemporary English life, that would be deeply concerned with human institutions and man's role in society. He thus attempted to banish the divisions between high and low art by painting scenes from

notorious villains of the day. Thackeray wrote of this swift journey from sin to retribution – 'The people are all naughty and bogey carries them off.' Yet Hogarth's satire constantly widens out from description of a particular abuse to a vision of a dark and evil society whose macabre violence manifests itself in disease, punishment and madness. In the *Tale of a Tub* Jonathan Swift described Bedlam as an image of society:

> Is any student tearing his straw in piecemeal, swearing and blaspheming, biting his grate, foaming at the mouth, and emptying his pisspot in the spectator's faces? Let the right worshipful the commissioners of inspection give him a regiment of dragoons, and send him into Flanders among the rest. . . . I shall not descend so minutely as to insist upon the vast number of beaux, fiddlers, poets, and politicians, that the world might recover by such a reformation . . .

A similar dramatic reversal of values is implied by the last scene of the *Rake's Progress*, where the rake dies in Bedlam. The maddest inhabitants are the fashionable onlookers, and there is a disturbing resemblance between the madmen and the horde of dancing masters, artists and professors who exploit the rake in an earlier scene.

The madness that Hogarth describes is a comment on society. Later in the century the Spanish artist, Goya, whose satire is directed against similar abuses – prostitution, forced marriages, corrupt clergy – used scenes of imprisonment, madness and torture as symbols of the human condition in a way that transcends social questions. Goya did not pile detail upon detail, but blew up tiny scenes and human expressions until they take on a terrifying bestiality; he surrounded his figures with a vast darkness in which the monsters of the human imagination lurk.

Hogarth's satiric method owed much to Jan Steen – the emblematic detail, the pictures within pictures – but his fancy is more flamboyant, his imagery more overwhelmingly alive. Hogarth's figures, true to the dictates of history painting, enact their drama, somewhat stagily, through expression and gesture. They are accompanied by a host of objects, which lead the eye into every nook and cranny, obliging us to read inscriptions, names and labels. The objects are not only symbolic but have a weird, almost expressionist vitality. Lamb spoke of 'the dumb rhetoric of the scenery – for tables, chairs and joint stools in Hogarth, are living and significant beings'. The rooms themselves, especially in *Marriage à la Mode*, have an overwhelming presence: objects invite us to share their horror – a painting of Medusa's head goggles in outrage, a skeleton in a cupboard whispers into the ear of a stuffed man, ornaments seem to caper and sneer in salacious disapproval. The paintings on the walls, old masters of rape, torture, and cruelty, add a silent commentary on the irrelevance of the

Goya: *Two Old Men Eating,* 53 × 85cm, 1820–3

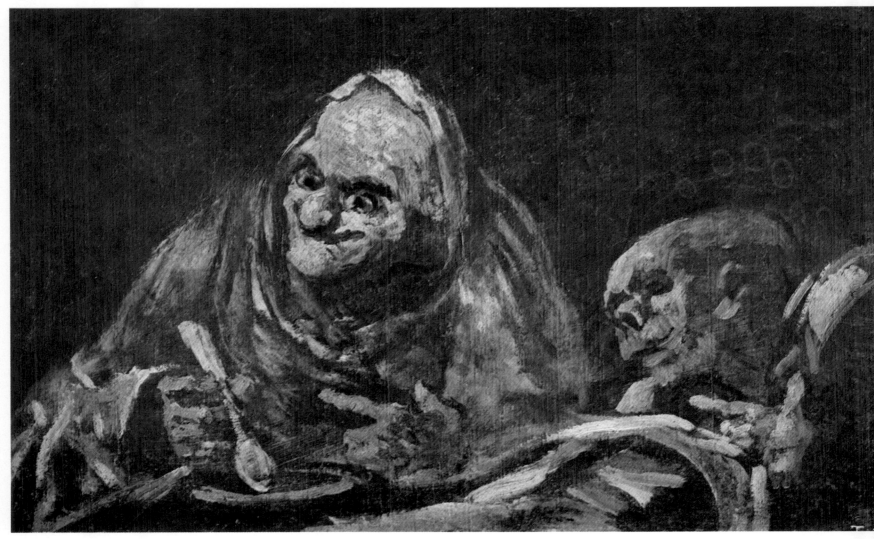

This is one of ten tapestry designs for the palace of El Pardo, Madrid, a series which first made Goya's reputation. Goya chose themes of ordinary country life, and the acceptance of such subjects by the Spanish royal tapestry factory is evidence of the eighteenth century's deep desire for informality and naturalism. The two charming, and yet somehow amusing and human, figures are posed before a feathery tree and decorative rococo landscape; they are inhabitants of an enchanted and delightful world. Later cartoons are less brightly coloured and cheerful and begin to incorporate a sense of the harsh realities of the peasant's existence.

Piazzetta: *The Young Flag Carrier*, 87 × 66cm, early 18th century

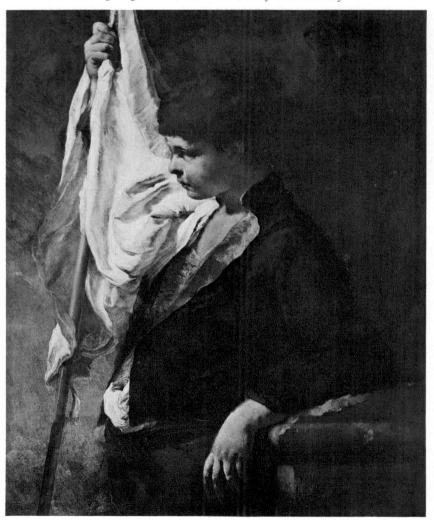

heroic ideal to modern bourgeois life. Hogarth, like Swift, Pope and Fielding, was drawn to the mock-heroic, and his low-life themes imply a contrast, brought out by visual puns and allusions, to the conventions of high art.

An interest in the doings and behaviour of the common man had appeared only spasmodically among Italian artists of the seventeenth century, and since the late sixteenth century there had been a tendency to turn the sober appraisals of Northern painters into bawdy or ribald jokes. In the early eighteenth century more artists became interested in such themes, and both Giuseppe Maria Crespi and his pupil, Piazzetta, produced some exceptionally fresh and direct paintings of ordinary people, touched with real tenderness. Yet their achievement remained exceptional, and separate from the predominant tendencies of specialist artists. These artists, in very general terms, lacked the spontaneity and unconventional freedom achieved elsewhere in Europe in the eighteenth century. They remained uninterested in describing environment; their primary interest was in figure painting, and both figures and ex-

Goya: *The Milkmaid of Bordeaux*, 74 × 68cm, 1827

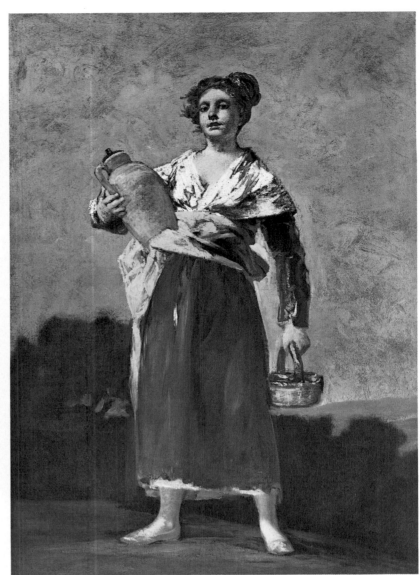

Goya: *The Water Carrier*, 68 × 50cm, c.1810–12

pression often suggest a rather deadening dependence on academic formulas. There is little warmth of sympathy; Italian painters tended to add spice to reality, using it as the starting point for macabre visions or for grotesque farce or parody. The morbid imagination of the Genoese painter, Alessandro Magnasco, transformed torture chambers, scenes of the Inquisition, synagogues, even Quaker meetings, into weird and flickering fantasies. The Lombard Giacomo Ceruti painted, without sympathy or humour, in sharply disturbing detail but with little attempt to describe a setting, a sordid and depressing array of beggars, idiots, cripples and dull and exhausted peasants. It was in Lombardy and the Venetian hinterland that a tradition of scenes of low and bourgeois life was most firmly established. In Naples

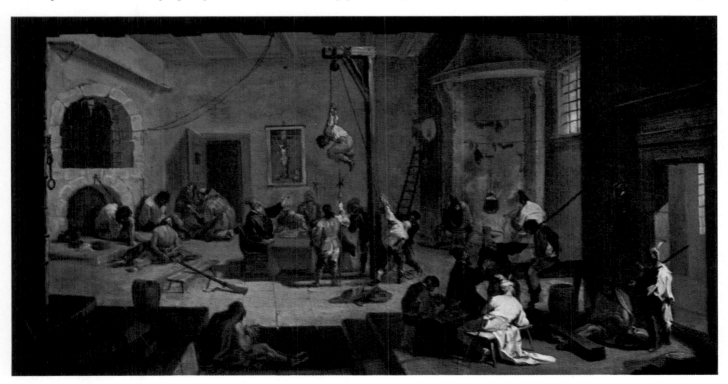

Magnasco: *Torture Chamber*, 44 × 85cm, and detail (pages 54–5)

Gaspare Traversi painted scenes from the life of the middle classes. The remnants of a Caravaggesque tradition of shadowy backgrounds and of intense and compelling observation of physical detail within an abstract setting are very marked in these paintings. Often, against a dark background, three-quarter length figures are brought up close to the frontal plane; the figures are crowded together and the arrangement in space is often irrational. The main emphasis in Traversi's paintings is on expression, and it is this that creates a sense of tense communication between the loosely arranged figures. Traversi's works are lively and have a touch of irony and farce, but they are not realistic; their mixture of the shadowy and the concrete is disturbingly ambiguous.

It is only in the works of the Venetian Pietro Longhi that one finds modern, truly eighteenth-century scenes of everyday life. Longhi's main claim to fame is that he resisted the tired themes of the late Rococo in Venice and introduced a new kind of subject — small scenes of domestic and public life in contemporary Venice. Longhi showed the social round of the Venetian aristocracy — visits, concerts, hair dressing, dress making; unlike Traversi, he was interested not in individual expression but in capturing the feel of the

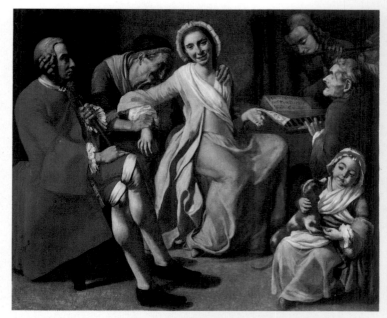

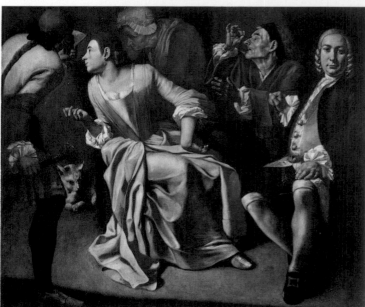

ABOVE **Traversi**: *The Concert*, 130 × 145·5cm, mid-18th century
BELOW **Traversi**: *The Secret Letter*, 131 × 146cm, 18th century

Zais: *Concert Champêtre*, 18th century

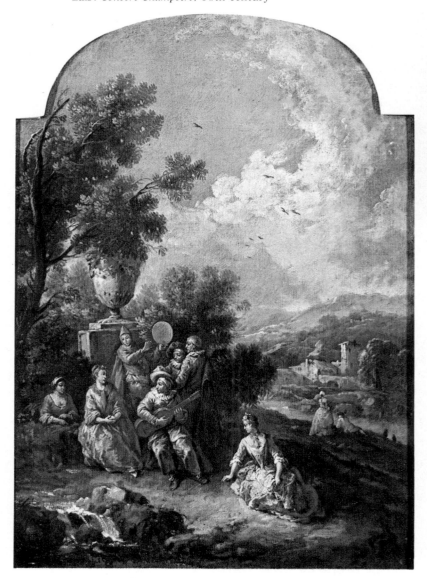

whole milieu; he recorded with minute particularity details of furnishing and décor. The world he described was stuffy and claustrophobic, conservative in the extreme and lacking any brilliance or grace — a world that contrasts sharply with the pageantry and gaiety of the public Venice of Guardi's works. Longhi's figures are stiffly posed and stare somewhat blankly out of the paintings; the tiny events and incidents that link them together seem inadequate to fill their days. Unlike Hogarth, Longhi does not comment or satirize; unlike Watteau, his works have no magical charm; he painted what he saw of a limited section of society and perhaps the hesitant suggestion of boredom and aimlessness itself presages change.

In the second half of the eighteenth century, an important change in attitude occurred in the works of Jean-Baptiste Greuze. By this date the devotees of the cult of sensibility had reacted violently against the trust in reason and the intellect that had characterized the early years of the century. The novels of Samuel Richardson, with their confidence in the

triumph of virtue and their stress on moral instruction, were popular in France. In 1761 Rousseau, the great apostle of feeling, published *La Nouvelle Héloïse*. Diderot demanded that the artist should move us to passionate outbursts of emotion: 'Move me, astonish me, unnerve me, make me tremble, weep, shudder, rage, then delight my eyes afterwards, if you care to.'

No better outlet for displays of sentiment could be imagined than family life, and particularly the simple family life led in the country. Novels and plays on this theme conditioned a sophisticated Parisian public to wallow in the paintings of Greuze. His famous works, *The Village Wedding, The Paralytic, the Well-Loved Mother*, are painted with a wistful nostalgia for a lost world of rustic innocence and filial obedience, where healthy and devoted children live in domestic peace with their venerable and aged parents. Greuze's close connexion with literature and the theatre is apparent in his use of rhetorical gestures and in his stage-like settings, with their suggestion of the *tableau vivant*. He is, too, concerned above all with telling a complex story; in *The Paralytic* every incident is calculated to add to the tender and affecting emotion expressed. In the 1770s Greuze's paintings became harsher and shared some of the melancholy gloom of early Romanticism; like Hogarth, he was deeply dissatisfied with the low repute of his subject matter, and the more sombre and didactic elements in his work were intended to give them the seriousness of history painting.

The implications of Greuze's more serious treatment of the tragic possibility of domestic drama were not immediately appreciated; the gravity of his late style was overwhelmed by the advent of Neo-classicism and the

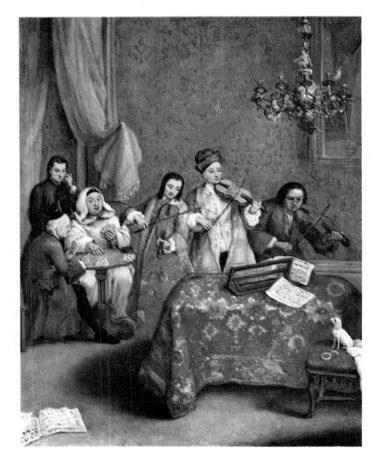

Longhi: *The Concert,* 60 × 48cm, c.1741

BELOW LEFT **Longhi:** *The Dancing Lesson,* 60 × 49cm, c.1741

Longhi: *The Apothecary's Shop,* 60 × 48cm, c.1752

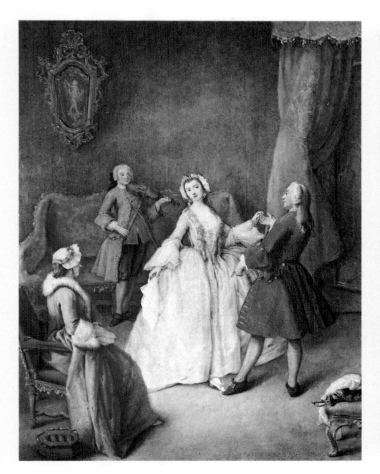

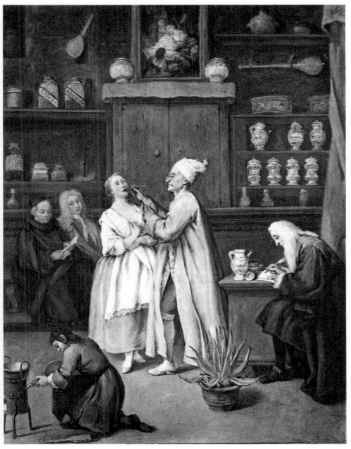

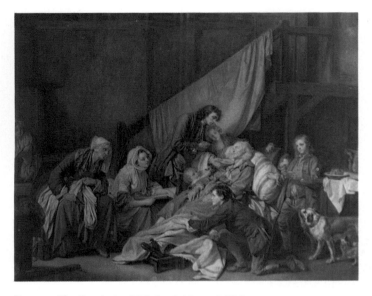

Greuze: *The Paralytic*, 115·5 × 146cm, 1763

political radicalism and heroic treatment of insignificant contempory events was to arouse bitter controversy, declared, 'Realism is in essence the democratic art.' He wanted 'to be able to represent the customs, the ideas, the appearance of my own era according to my own valuation; to be not only a painter but a man as well; in short to create a living art: that is my aim'. Few seventeenth-century Dutchmen intended to change society; yet Courbet and the peasant painter, Jean-François Millet, wanted to confront their era with its inequalities and injustices, and to hold up to it its own image, however ugly and however threatening. Despite these basic differences, both artists and novelists saw their precursors in Dutch art, and at this period the word, *genre*, meaning kind or sort, began to be widely used to describe Dutch paintings of everyday life; it was generally

Courbet: *The Beautiful Irish Girl*, 54 × 65cm, 1866

austere style of David. The early nineteenth century, however, saw the death of history painting; the growth of democratic ideas, a new and broader approach to history, which embraced the life of the common man as well as kings and heroes, led to the demand for subjects of contemporary relevance. The cry, *Il faut être de son temps*, was to resound throughout the nineteenth century.

In the mid-nineteenth century, for the first time, realism was transformed into the dominant artistic movement; its theoretical basis lay in the idea that the work of art is an imitation or mirror of the world outside. We have little idea of what Dutch seventeenth-century realist artists thought they were doing; the theoretical writings of the period were classicist. Nineteenth-century realists, however, were concerned to draw up a programme; Gustave Courbet, whose

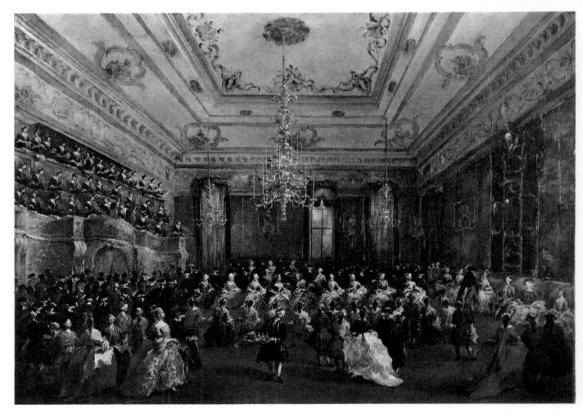

Guardi: *Concert in Venice*, 68 × 91cm, 1782

believed that the Dutch artist had simply recorded the world around him, without theory or thought.

As 1848, the year of revolutions, approached, the peasant worker, that incarnation of the power of 'the people', became an artistic theme of ever deepening significance. Throughout nineteenth-century art the poor and the dispossessed are shown movingly as images of the condition of man. The laundress struggles with unwieldy bundles of clothes; the peasant labours under a load of faggots; man is reduced to anonymity by repetitive and backbreaking labour – ironing, stone breaking, gleaning, resting on his hoe; the fallen woman, the pauper, the saltimbanque.

Wilkie: *The First Ear-ring.* 73 × 58cm. 1835

Courbet: *Burial at Ornans.* 314 × 663cm. c.1849–50

Courbet saw this painting as one of a series which should record rural life in his native Franche-Comté. The burial takes place in the new graveyard on the outskirts of Ornans; the participants include the mayor, Courbet's father, and, in the front row towards the right, his three sisters, their faces covered by handkerchiefs. It is a prosaic and unidealized record of the small-town bourgeoisie, firmly located in time and place. The composition is startlingly simple. Courbet was inspired both by seventeenth-century Dutch group portraits and by the repetitive forms of popular art. Each figure is clear and distinct, and sentiment is mixed with humour in the characterization of the red-nosed beadles and priest. The lack of declared significance and of any reference to the transcendental has led to complex political interpretations. Yet its sheer size and directness suggest that Courbet was trying above all to bring to the random experience of simple people the deep seriousness of the history painter.

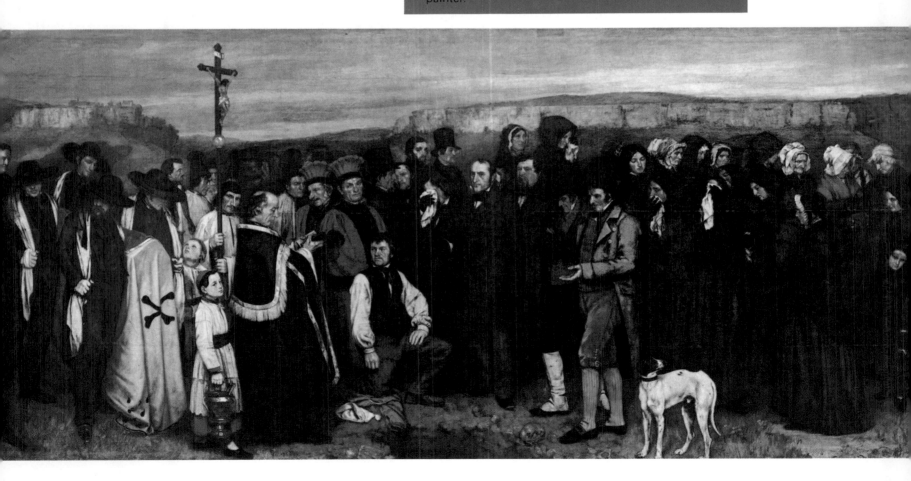

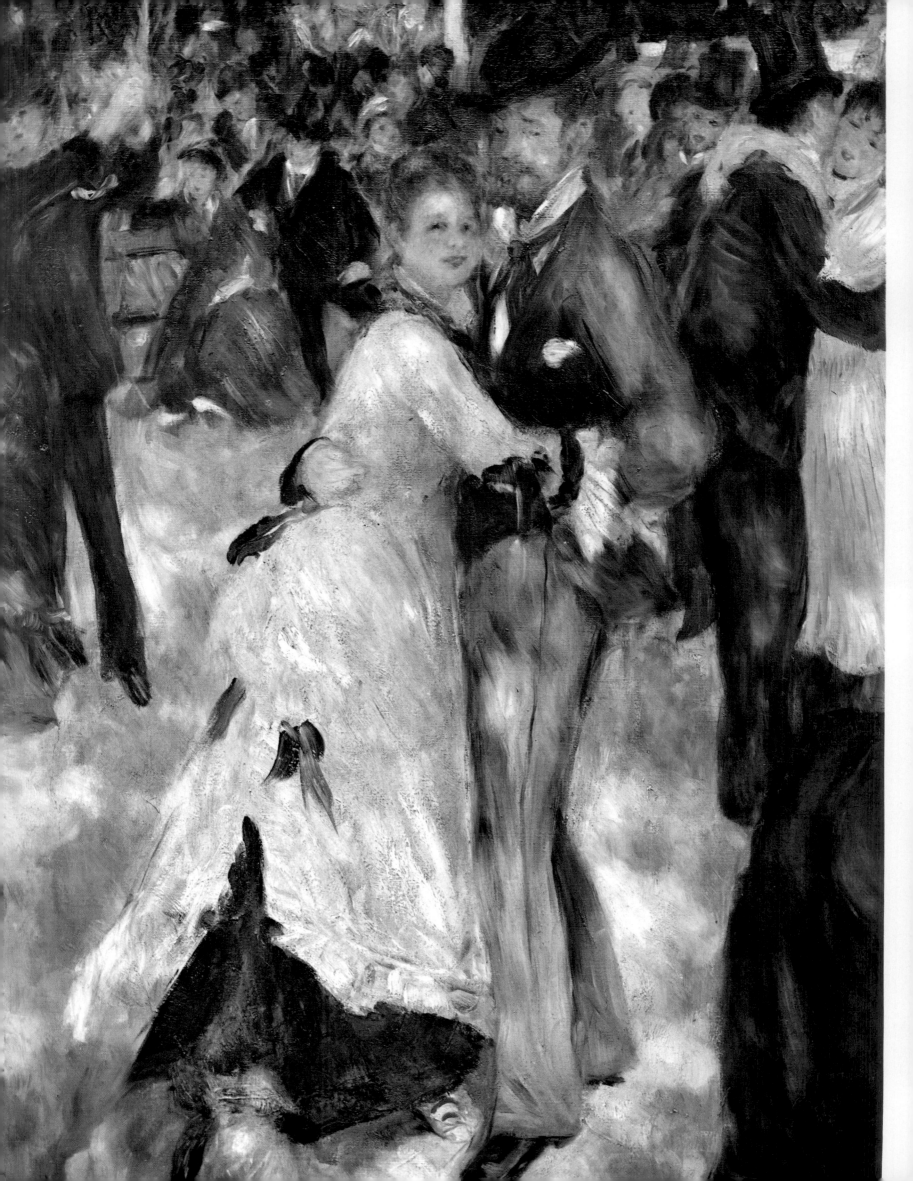

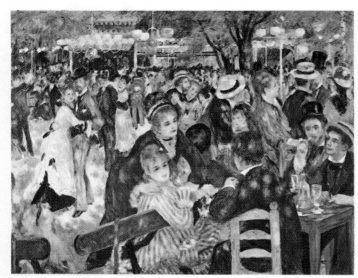

Renoir: *Le Moulin de la Galette*, 131 × 175cm, 1876

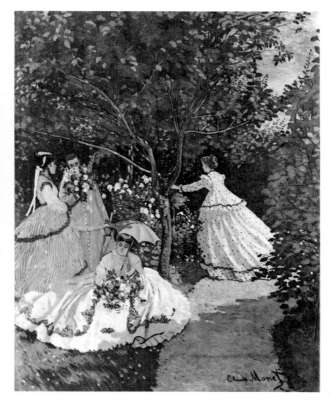

Monet: *Women in the Garden*, 255 × 205cm, 1866

outcast and exiled, wander on the earth. Millet wrote emotionally of his fatalistic view of the peasant as beast of burden:

> You are seated beneath the trees, enjoying a sense of well being and tranquillity, you see emerging from a small path a pitiful figure burdened with a faggot, the striking and unexpected appearance of which takes you back instantaneously to the sad fate of man, Weariness.

Both Courbet and Millet attempted to show that simple people could be painted with the same profound significance as the great events of the bible or mythology. The sheer size of *The Burial at Ornans* — more than forty-five life-size figures are spread out in a great frieze over twenty-four feet long — establishes its claim to be raised into the category of history painting. Castagnary, the realist critic, wrote in connexion with Millet:

> The modern artist has acquired this conviction, that a beggar beneath a ray of sun is in a condition of beauty greater than a king on his throne; that a peasant going to work beneath a clear sky in the cold morning has the religious solemnity of Jesus on the mountain.

The artist no longer moralized or satirized, but the stress on

truthfulness, on a detached and objective description of everyday reality, was itself deeply moral. George Eliot protested against idyllic and false treatments of the peasant that served to strengthen the divisions in society, and in *Adam Bede* wrote passionately:

> It is for this rare, precious quality of truthfulness that I delight in many Dutch paintings which lofty-minded people despise. I turn, without shrinking, from cloud-borne angels, from prophets, sibyls, and heroic warriors, to an old woman bending over her flower pot, or eating her solitary dinner, while the noonday light, softened perhaps by a screen of leaves, falls on her mob cap and just touches the rim of her spinning wheel, and her stone jug, and all those cheap common things which are the precious necessaries of life to her.

Millet declared that he simply wanted to paint peasants as

Daumier: *The Good Vintage*, 22 × 29cm, mid-19th century

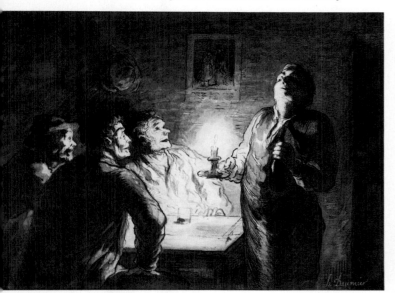

Pages 62–3. **Manet:** *Olympia*, 130 × 190cm, 1863

A young prostitute, lying on a couch, receives a token of admiration brought to her boudoir by a negro servant. The theme was an important one in Realist iconography, and there are many Realist novels about the prostitute, such as Dumas' *La Dame aux Camélias*, 1852. A further parallel may be drawn with the triumphant revival of Verdi's opera, *La Traviata*, in 1854, in which a grand opera primadonna was audaciously required to play the part of a contemporary courtesan. In Manet's work the pictorial type of a Titianesque Venus is transformed into an immediate portrayal of the role of the demi-mondaine in the social life of the times. The central theme of Verdi's opera is the pathos of the courtesan's situation. Manet's hard-eyed girl seems in little danger of dying from consumption, and the elegant artificiality created by the orchid, the black cat, the mules and velvet ribbon suggest an atmosphere of luxurious perversion that reminds us of Baudelaire's erotic poetry.

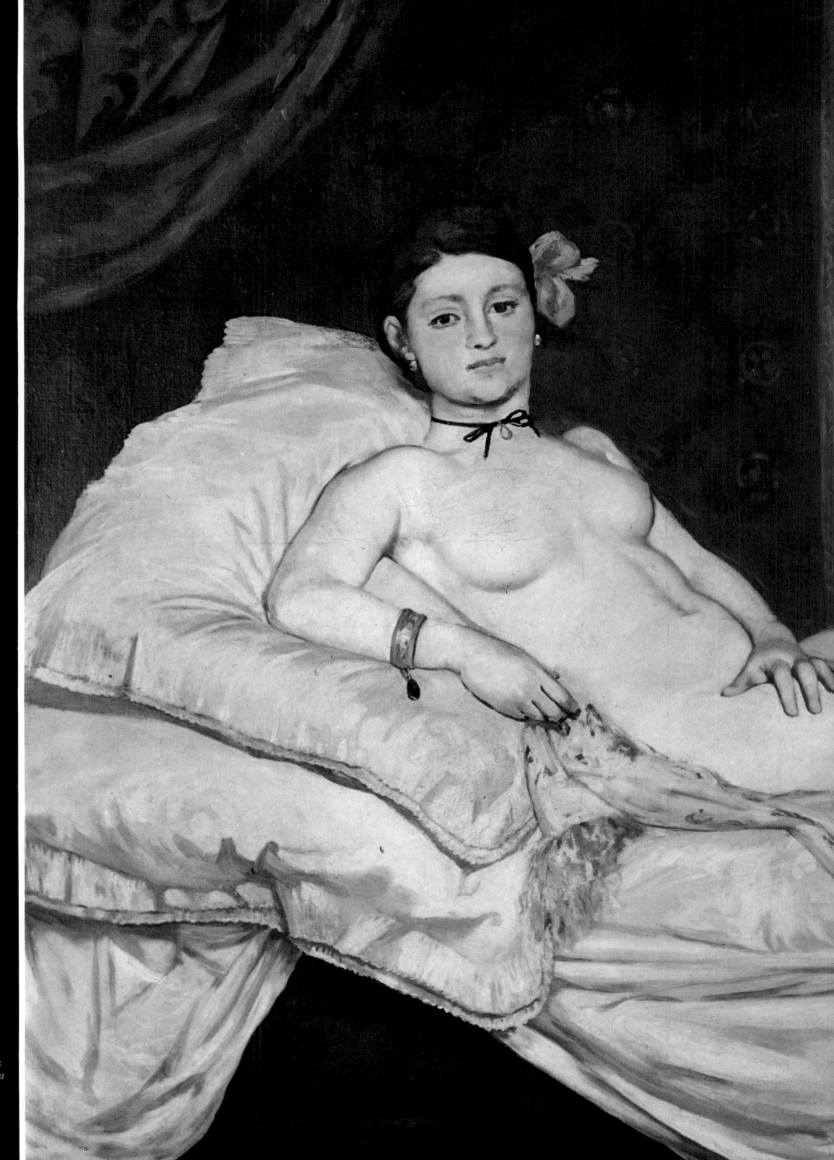

Manet:
Olympia

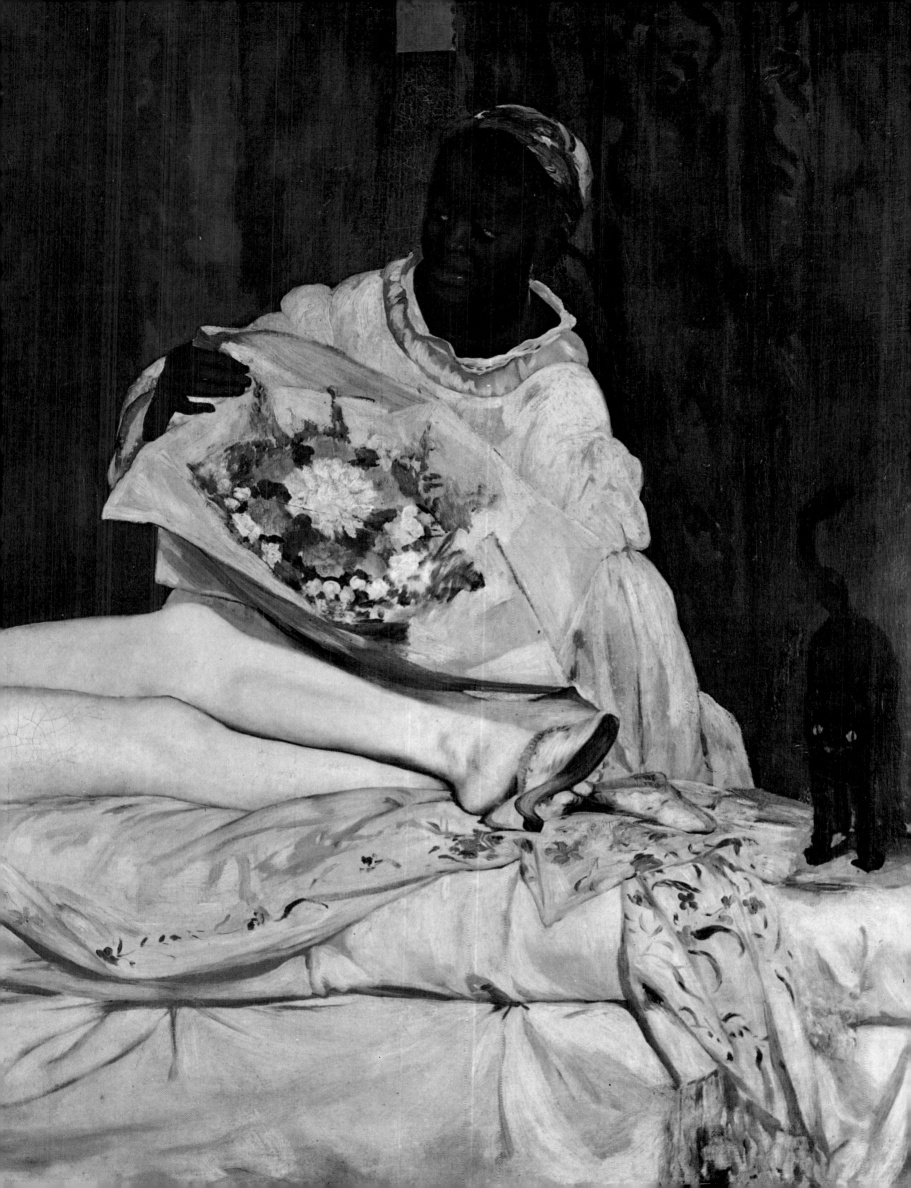

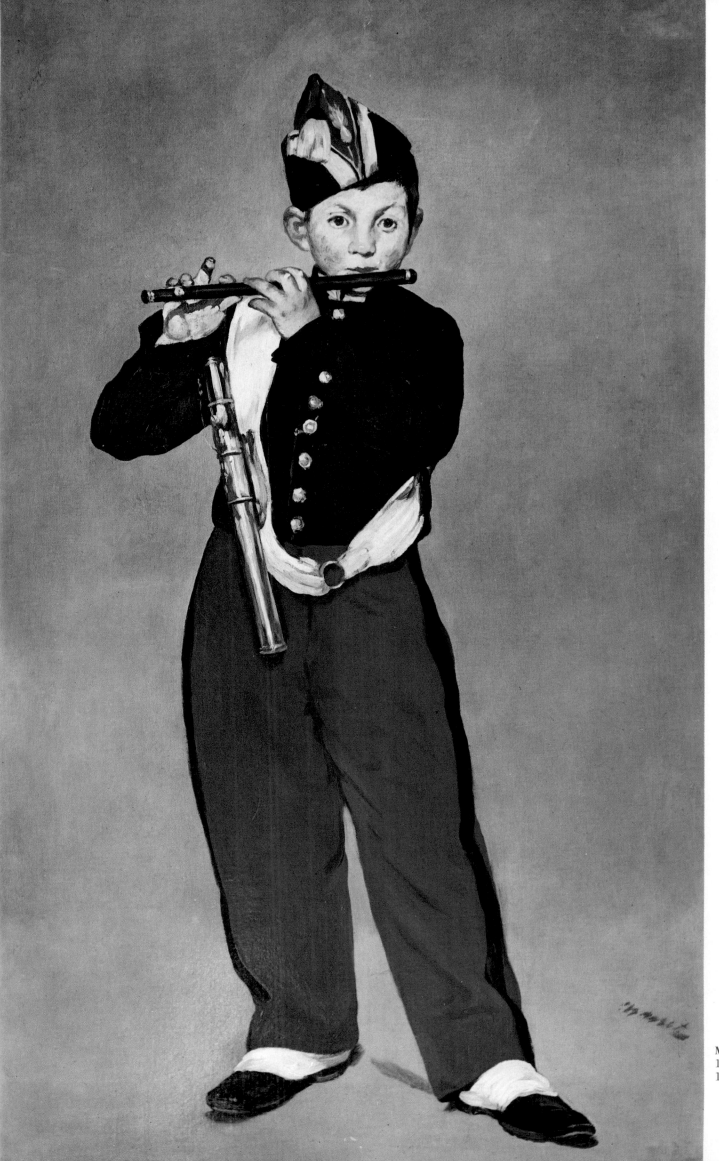

Manet: *The Fifer,*
161 × 97cm.
1866

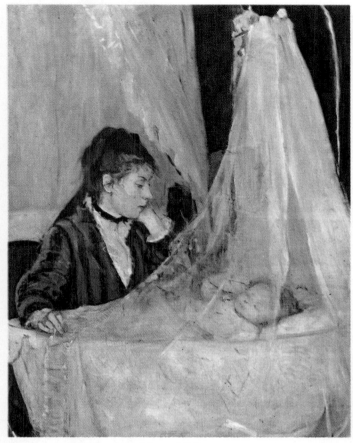

Morisot: *The Cradle*, 56 × 46cm, 1873

Manet: *Young Man Peeling a Pear*, 85 × 71cm, 1868

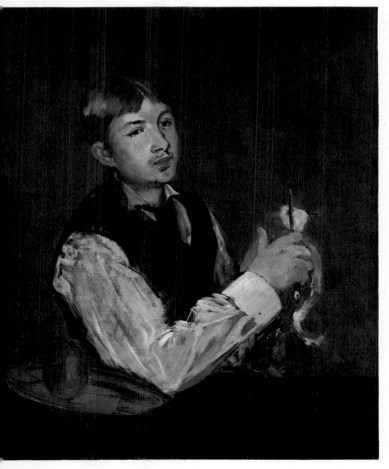

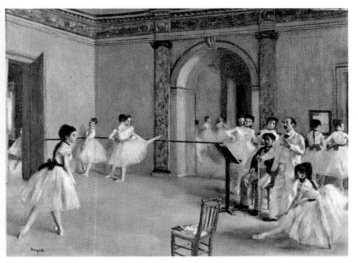

Degas: *The Foyer at the Opéra*, 32 × 46cm, 1872

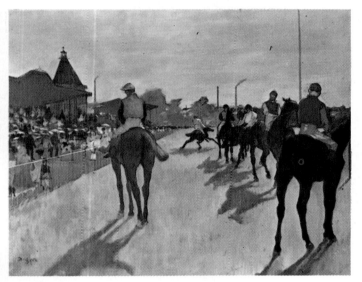

Degas: *Jockeys before the Grandstand*, 46 × 61cm, 1869–72

they were, labouring and exhausted. Courbet's style, with its debts to Dutch art and to the simplicity and naivety of popular art, its rather awkward, stiff figures, its lack of rhetoric and of the traditional methods of composition, was an attempt to capture truthfully the randomness of everyday life.

Significantly, the realists of the 1840s and 1850s, despite their demand for contemporaneity, did not record the most stirring events of the day; there are no paintings of the modern city, with its factories, workers and machinery. Millet's labourers stood for a biblical and virtuous reality that resisted the onslaught of modern technology. There was no tradition of urban painting available; the demand for a new style that should capture the new tempo of modern life was made by Charles Baudelaire in his moving essay, *The Painter of Modern Life*, about the fashionable illustrator, Constantin Guys. Baudelaire says Guys' principal characteristic is his passionate curiosity – his fervent desire to fling himself headlong into the crowd and to breathe in 'all the odours and essences of life'. The essay captures the transitory and fugitive beauty of modern Paris to whose manifold impressions the artist should submit with 'childlike perceptiveness – that is to say, a perceptiveness acute and magical by reason of its innocence'. Baudelaire's descriptions read like a prophecy of Impressionist painting of the 1870s –

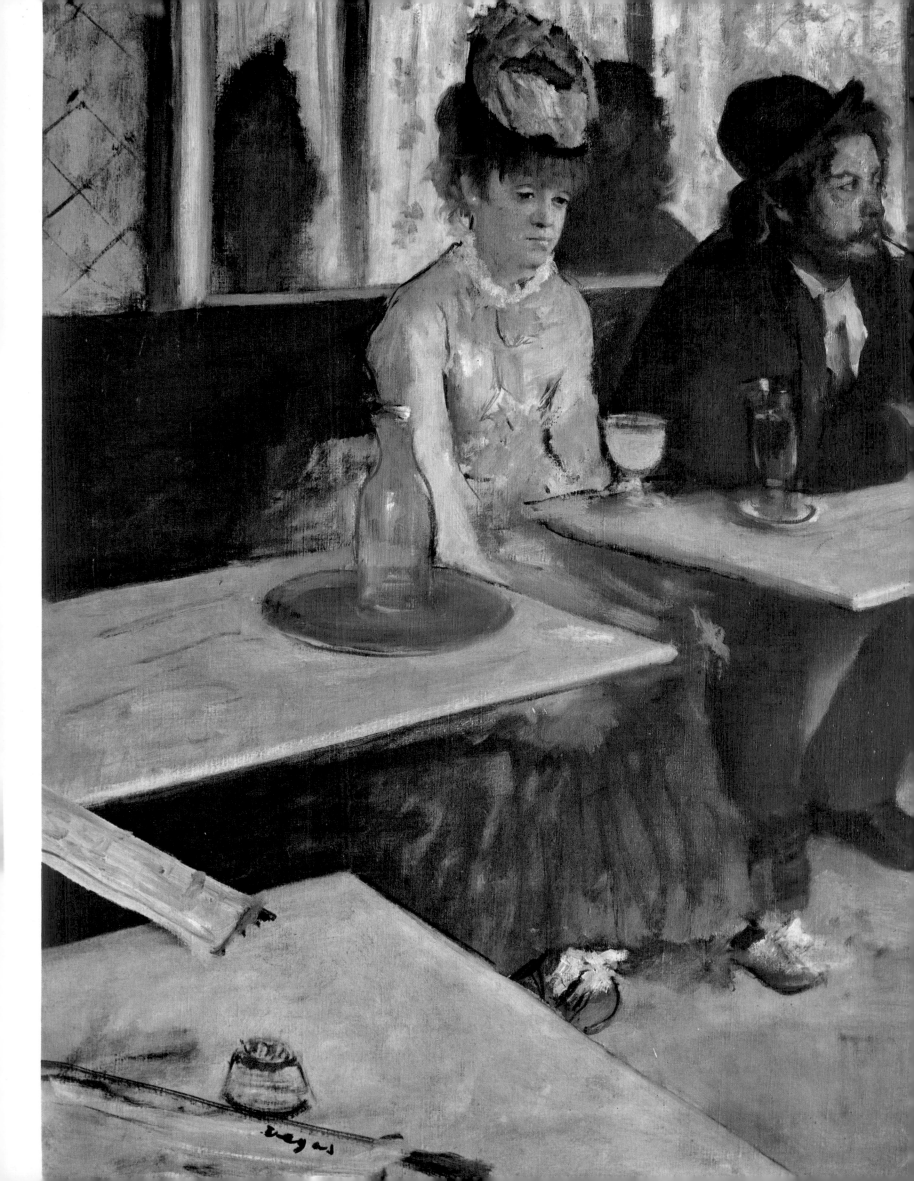

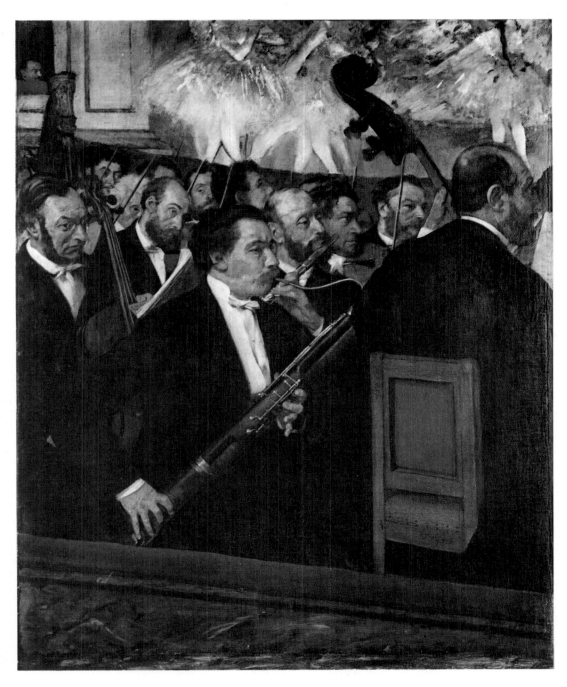

Degas: *Musicians at the Opéra,*
56·5 × 46cm, 1868–9

Opposite **Degas:** *Absinthe,* 92 × 68cm, 1876

The painting shows the interior of the Café de la
Nouvelle-Athènes, a rendezvous for the Impressionists
in the 1870s. After about 1870 Degas produced a
series of bold scenes of modern life, in which
ingenious and daring compositions show familiar
subjects in an unfamiliar light. Here the asymmetry and
zig-zag movement, perhaps influenced by Japanese
prints, convey a sudden and revealing glimpse of a
corner of life. The woman slouches over the table,
indifferent to her companion, and the atmosphere of
defeat, as has often been pointed out, recalls Zola's
Dram Shop. Degas associated a complex sense of
disillusionment and isolation with the modern sensi-
bility. His preference for the expressive possibilities of
interior space contrasts sharply with the natural
beauties of Renoir's *Moulin de la Galette.*

the 'landscapes of stone, caressed by the mist or buffeted by
the sun', the gas-lit evenings, the public gardens, and the
world of theatre and café. The women he describes remind
us of Degas — the little dancers, the singers seen against
magical sulphurous lights, the prostitute indulging in 'bouts
of tap room apathy' or when 'quite by chance, they achieve
poses of a daring and nobility to enchant the most sensitive
of sculptors, if the sculptors of today were sufficiently bold
and imaginative to seize upon nobility wherever it was to
be found, even in the mire'.

In the 1860s and 1870s a new kind of realism succeeded
the serious works of Courbet. Modernity became an aesthetic
rather than a moral concept. The Impressionist painters
turned to Paris, to views of its boulevards, railway stations,
theatres and sidewalk cafés; they painted the Parisian
suburbs, where city dwellers could escape to the pleasures
of picnicking and boating; they painted the holiday atmos-
phere of seaside resort and racetrack. Both Manet and Degas
attempted to create a new pictorial structure to capture the

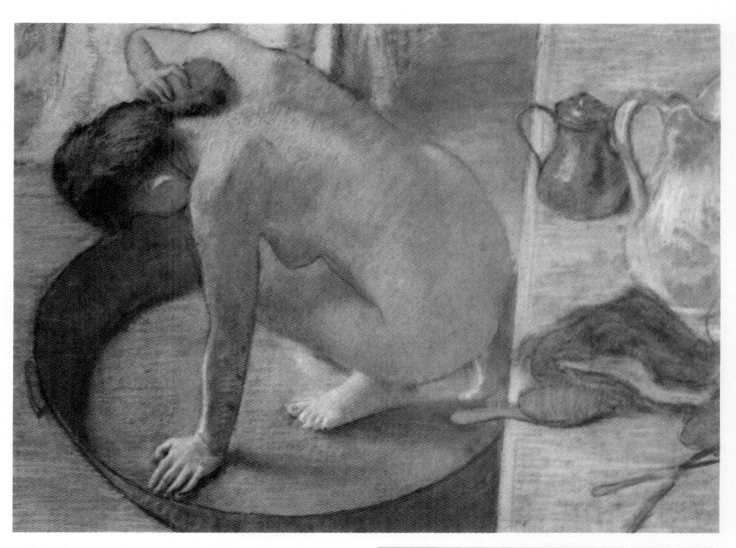

quality of perpetual movement, vitality and social contrast afforded by the spectacle of modern life. They created compositions that underline the random nature of their observations, and Degas frequently used unusual angles of vision, focusing a sideways glance on his subject, and exploiting the effects of abrupt angles and oddly cut forms. Theirs is a detached attitude to reality, perhaps possible only

Above **Degas:** *The Tub*, 60 × 83cm, 1886

Baudelaire in 1846 had lamented that the artist did not paint the 'modern beauty of the nude' in everyday, contemporary situations – 'in bed, for example, or in the bath, or in the anatomy theatre'; he described 'Rembrandt's Venuses who are having their nails done and their hair combed with great boxwood combs, just like simple mortals'. Degas's series of pastels of the female nude splendidly fulfilled Baudelaire's demand. Degas himself said that he had tried to avoid poses that presuppose an audience, and painted his women 'as if you had looked through·a keyhole'. Here a woman washes her neck, and the spectator looks downward at her, as if pausing momentarily. There is a beautiful contrast between the roundness of her forms and the hard lines of the dresser with its rich still-life.

Degas: *Woman at her Toilet*, 75 × 72·5cm, c.1903

after the invention of photography. In Manet's works the significance of the subject is absorbed into a brilliant display of patterns of colour, light and brushstrokes. Degas' approach to contemporary subjects was drier and more analytical; he brought to the observation of a social type a telling anecdote, or a characteristic professional gesture — that quality of dispassionate curiosity that links him to the naturalist novelists like Zola, de Goncourt and Huysmans.

OPPOSITE **Cassatt:** *The Toilet*, 100·4 × 66cm

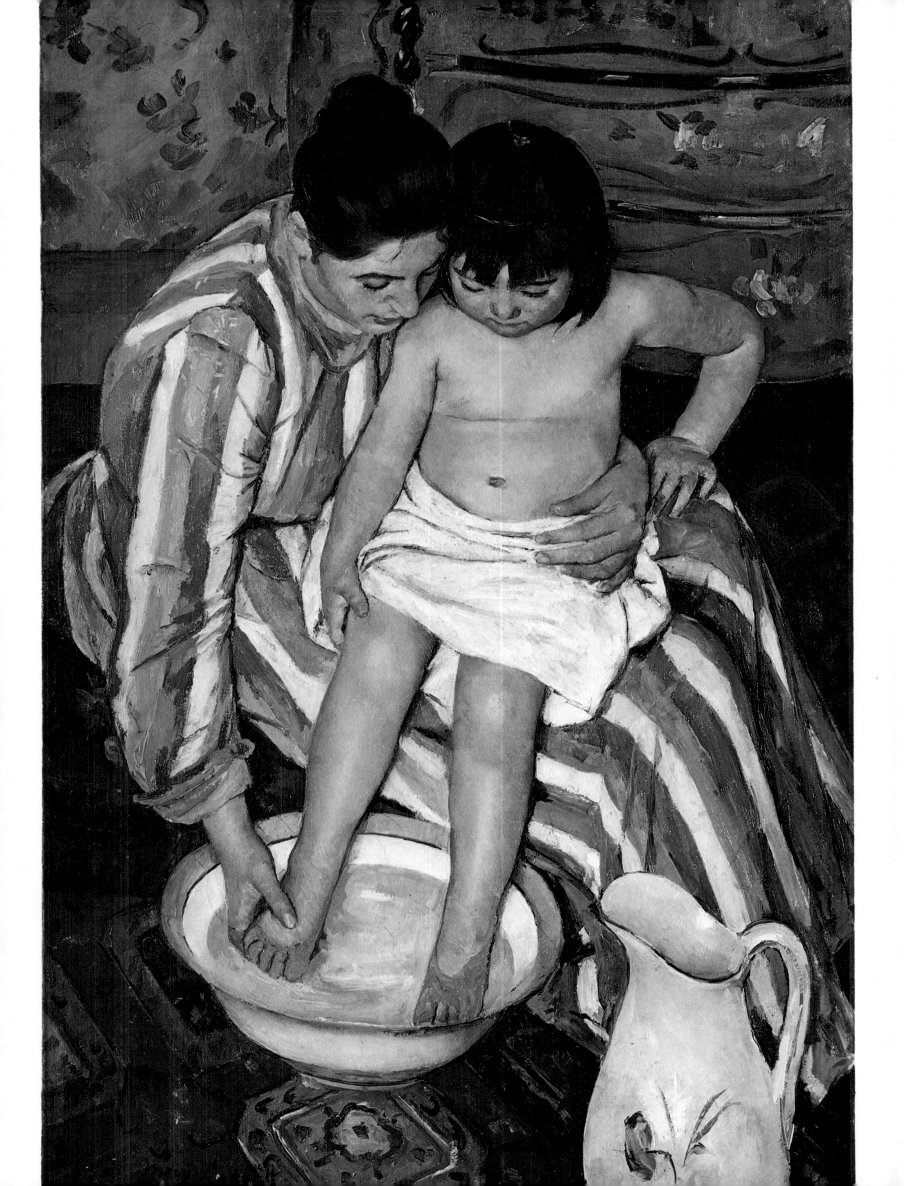

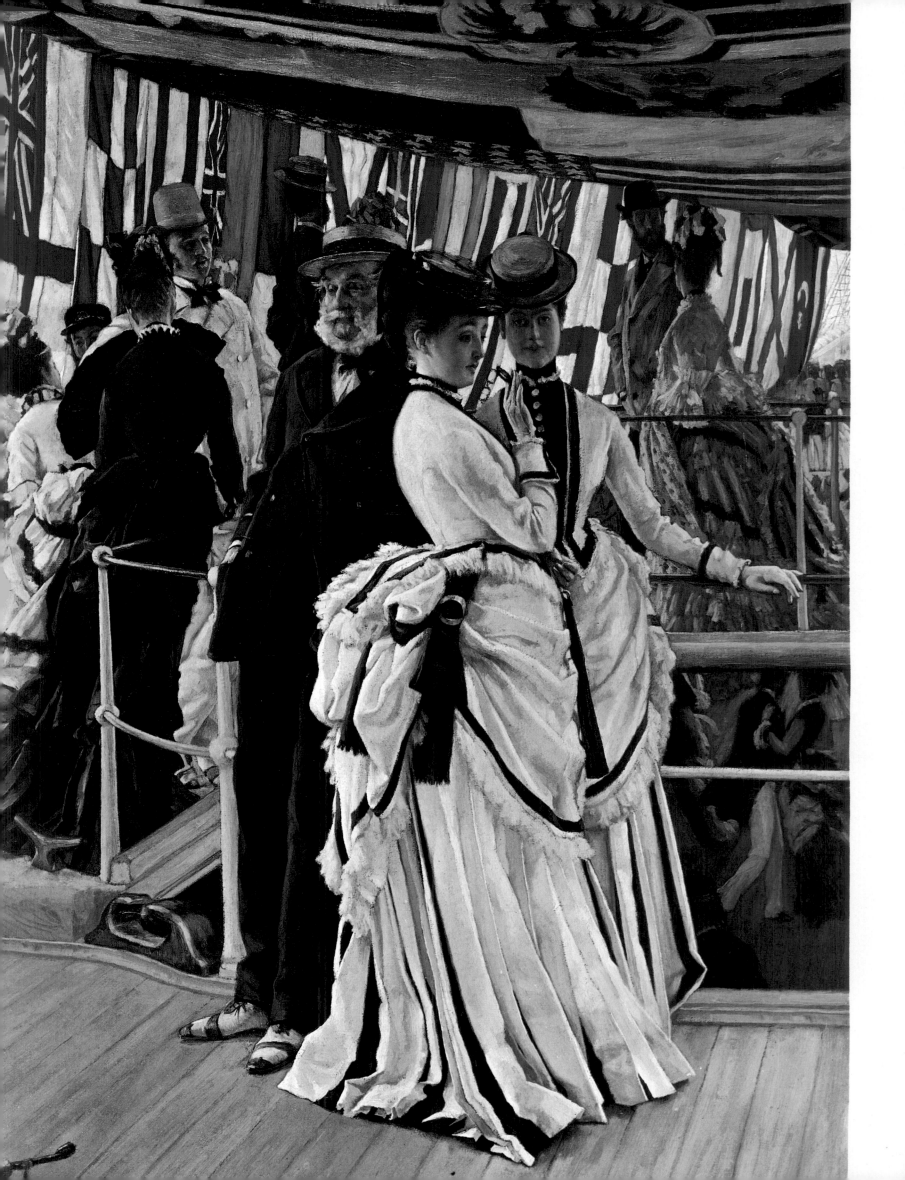

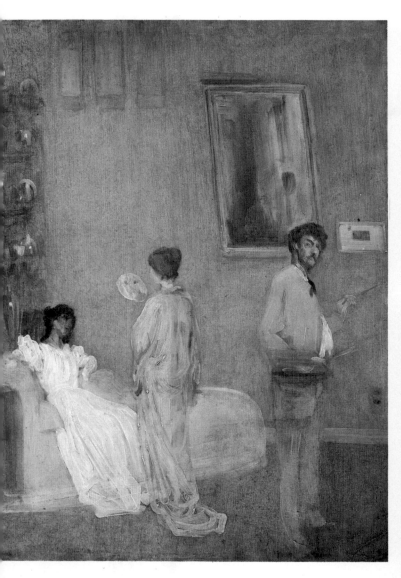

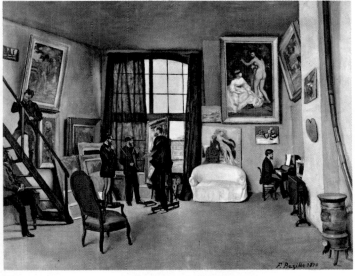

Degas' world is indoor and nocturnal, and he had a far
greater concern than any of this contemporaries with a
naturalistic description of milieu, of the precise appearance
of the banks, offices, and theatres that formed the back-
ground to modern life. His world has none of the glow of
Renoir's celebrations of suburban entertainment; often his
works communicate a sense of profound isolation that he
identified with the modern sensibility.

In the 1880s a widespread dissatisfaction with the

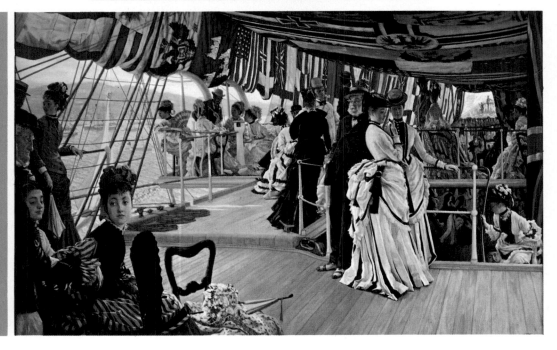

OPPOSITE **Tissot:** *The Ball on Shipboard* (detail)

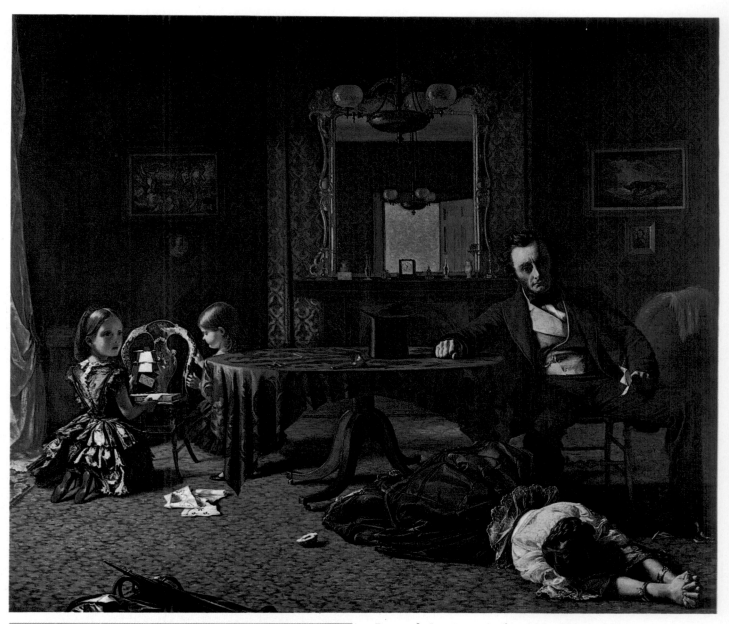

Bonnard: *Interior at Antibes*, 105 × 121cm, 1920

Egg: *Past and Present No. 1*, 63 × 76cm, 1858

Victorian scenes of everyday life tend to be the visual equivalent of contemporary literature; they tell a story, and represent in meticulous detail both figures and setting. This is the central scene of a triptych and shows the husband's discovery of his wife's infidelity. Five years later the husband died and the lateral scenes represent the children grieving for their lost mother, and the mother, clutching her bastard child, outcast and desolate in a vault on the river shore. The interior of this central panel is charged with hidden meaning; the open door, reflected in the mirror, through which she will soon pass, the half-eaten apple, the prints of the *Expulsion of Adam and Eve* and Stanfield's *Abandoned*, symbolize the woman's sin and retribution. The theme of the outcast and fallen woman became popular in the middle years of the century; the Victorian combination of prudish recoil and fascinated horror contrast sharply with French treatments of the theme of the demi-mondaine.

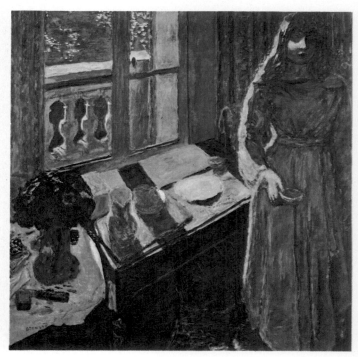

Vuillard: *Interior with a Seated Woman,*
44 × 38, 1904–5

Benson: *Rainy Day,* 63·5 × 76·2cm

Impressionists' overriding interest in optical perspicuity led many artists to seek a more abstract and spiritual art. Yet themes from everyday life do not entirely disappear. Georges Seurat's paintings of the life of the middle classes in the industrial suburbs of Paris have an up-to-the-minute modernity although they reject the snapshot spontaneity of the Impressionists. The peasant, symbol of a primitive power that might rejuvenate an oversophisticated society, became again an important artistic theme. Cézanne's *Card Players* have something of the simple grandeur of a Courbet; van Gogh saw the beginning of modern art in Millet rather than in Manet and in 1885 wrote: 'They started with a peasant's and labourer's figure as "genre", but at present, with Millet the grand master as leader, this is the very core of modern art.' His own paintings transformed observed fact

into a vision of a simpler and more radiant reality that should console the suffering and dispossessed.

In a sense, the paintings of Fernand Léger (and those perhaps of his successors, the Pop artists of the 1960s) are the end of a long tradition. Léger painted soldiers, men at work, common people at leisure; he adapted the formal devices of Cubism to stress the man-made quality of the modern world and modern man's place within it. The aesthetic irrelevance of subjects and traditions have been widely accepted in the twentieth century, and it is perhaps now as difficult to draw inspiration from everyday life as it is from the bible or mythology. The aesthetic debate that was central to the development of art from 1500 to 1900 is over and there are no longer any distinctions between high and low art.

Toulouse-Lautrec: *At the Moulin Rouge,* 123 × 140cm, 1892

Pages 74–5. **Seurat:** *La Grande Jatte,* 206 × 306cm, 1886

The theme of *La Grande Jatte* – the Sunday afternoon pleasures of an industrial suburb near Paris – may be likened to Monet's and Renoir's earlier paintings of boating, dancing and picnicking near the Seine. Yet Seurat's work seems a rebuke to their snapshot spontaneity. The extraordinarily luminous quality is achieved by a controlled dotting technique, and a sense of order and deliberate construction pervade the composition. The emphasis on a balance of horizontals and verticals, on full frontal or profile views, and the sophisticated use of multiple perspectives all give the painting a classic immobility; there is perhaps a tension between the wealth of sharply observed, even humorous details of dress and custom and the majestic finality of the organization.

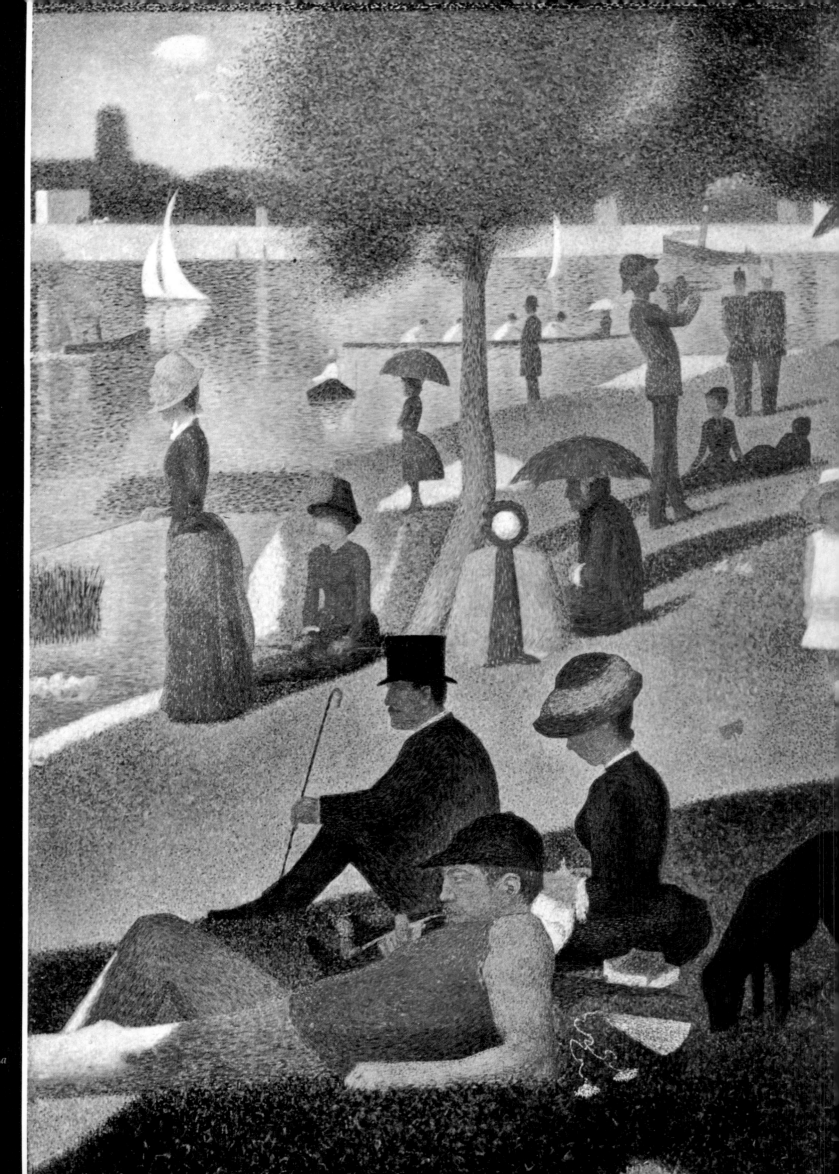

Seurat: *La Grande Jatte*

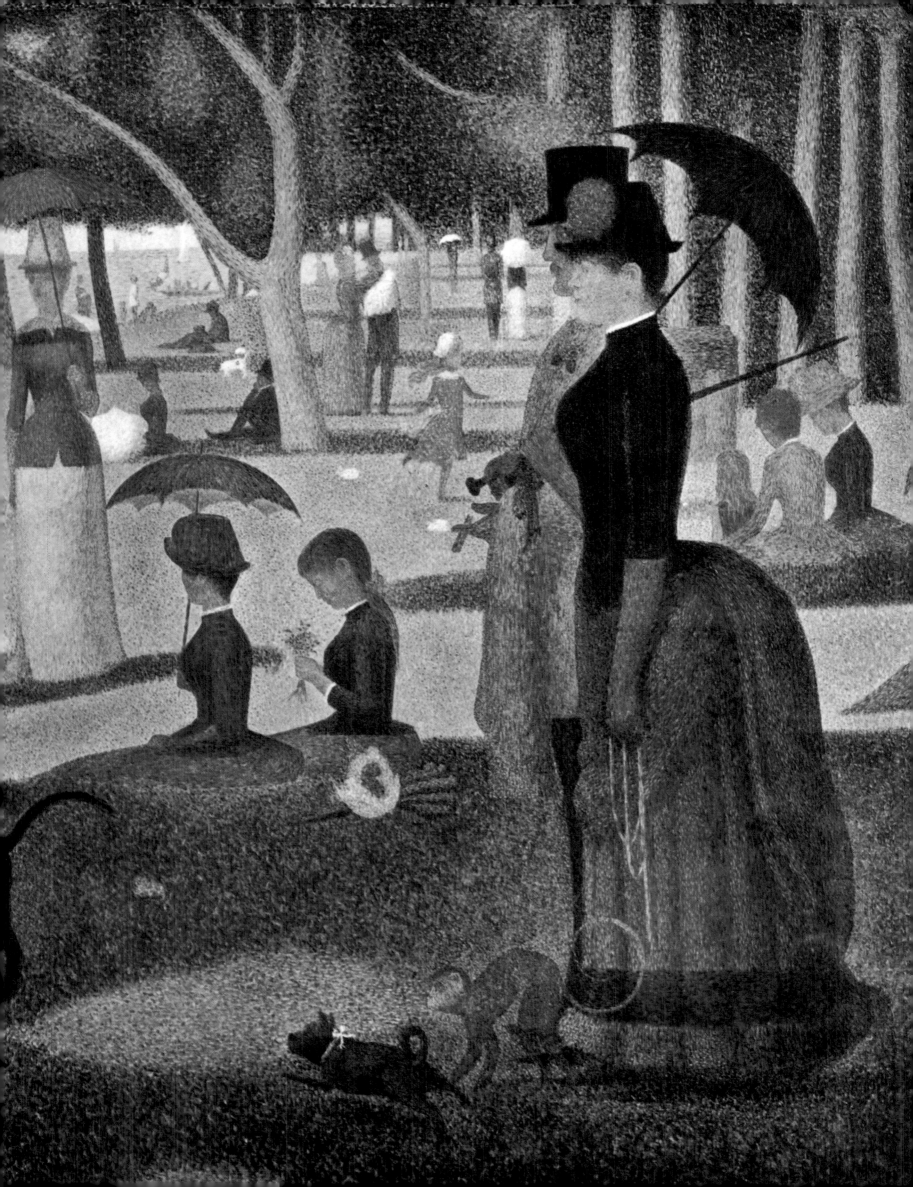

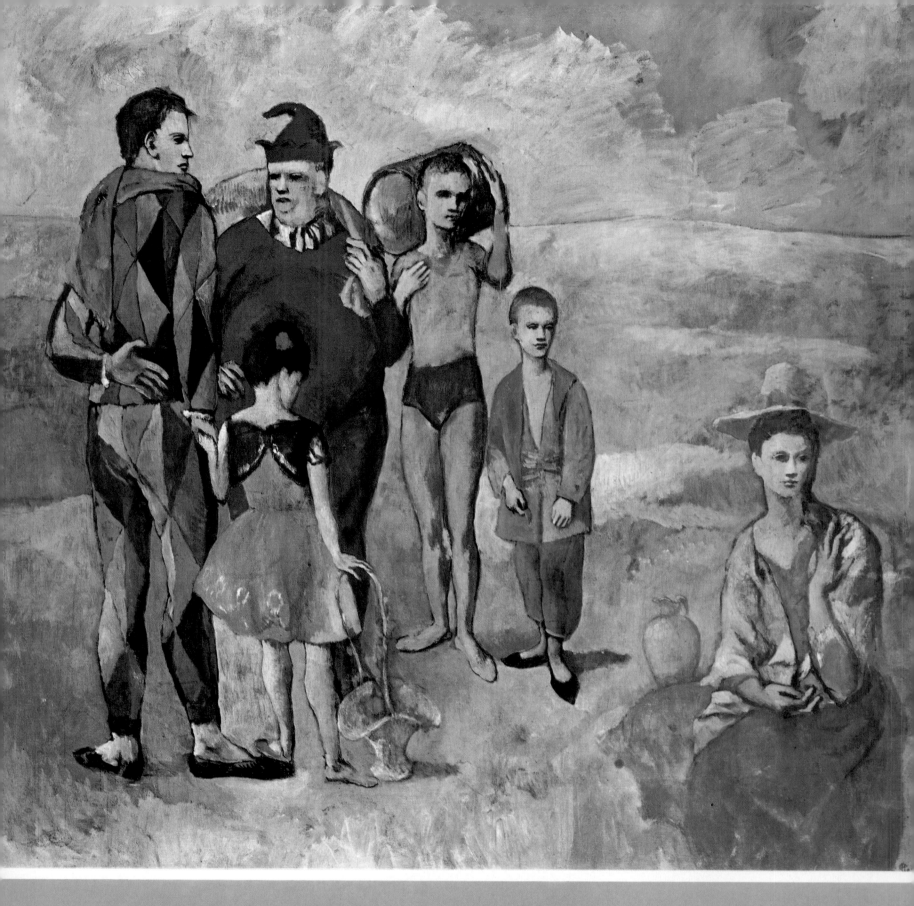

Above **Picasso:** *Family of Saltimbanques*, 213 × 229·8cm, 1905
Right **Picasso:** *The Blind Guitarist*, 122 × 83cm, 1903

The years 1901–4, which Picasso spent mainly in Barcelona, later came to be known as his Blue Period. Withdrawing from Impressionist immediacy, he began to paint generalized types of humanity, vagabonds, beggars, blind men — those solitary outcasts such as the one portrayed in *The Blind Guitarist*, whom he saw in the streets of Barcelona. The sense of the dignity of suffering, the introspective mood, and the elongated lines of the shoulders and head are intensely Spanish and perhaps indebted to El Greco. In 1905 Picasso's mood and

colour lightened, and he began to paint acrobats and their families with wistful tenderness; the Rose paintings have a rococo grace far removed from the Spanish gravity of the Blue Period. In sharp contrast to the vivid reality of circus paintings by Degas and Toulouse-Lautrec, a strange air of unreality and mysterious poetry hangs over Picasso's *Saltimbanques*. The landscape is deserted, and we are compelled to ponder over the identity of this odd group of people who are touched by melancholy, and a sense of evanescence.

OPPOSITE **Picasso:** *The Blind Guitarist*

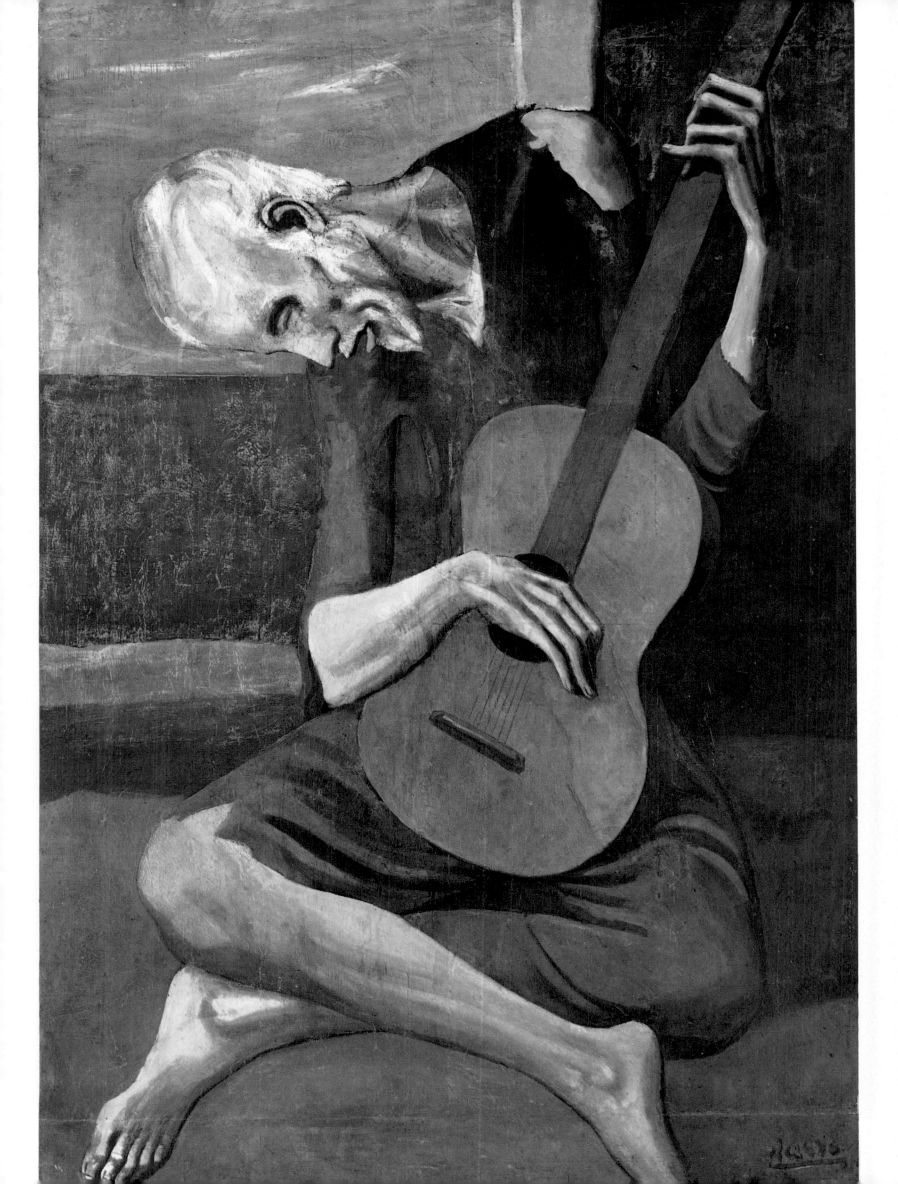

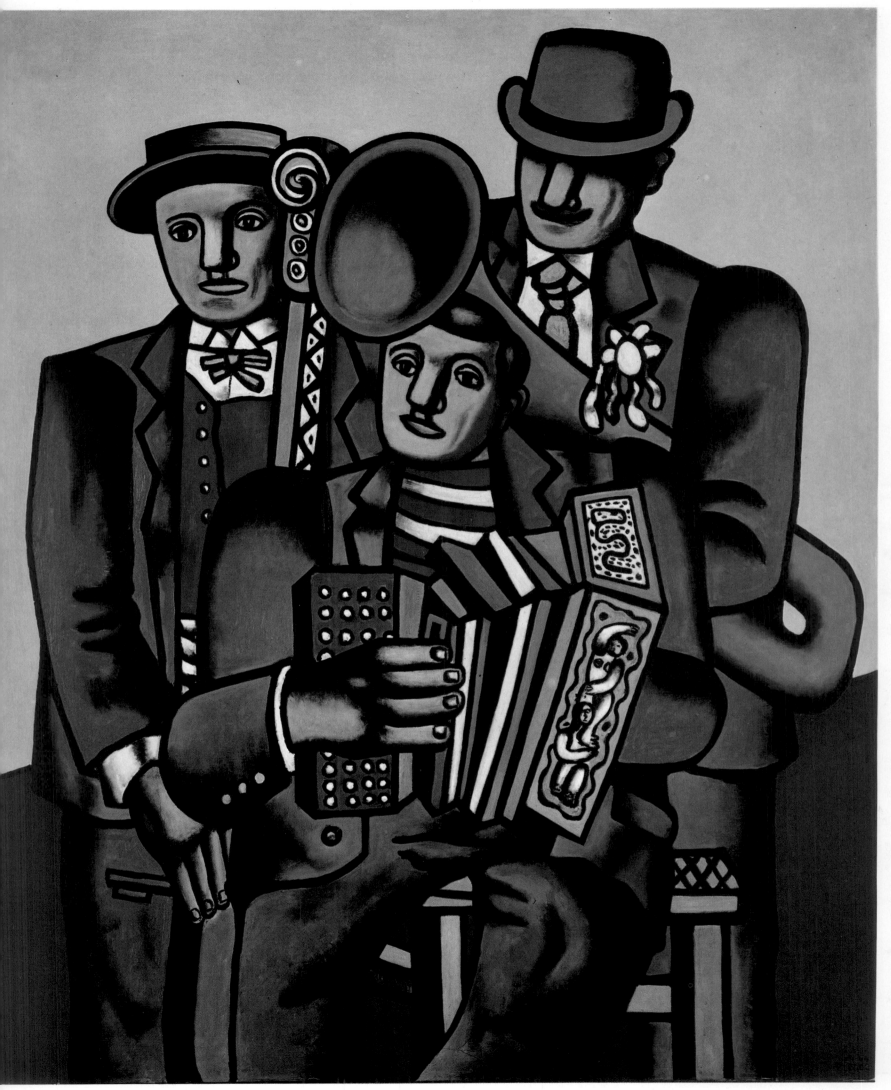

Léger: *The Three Musicians,* 147 × 145cm, 1944

Below **Léger:** *Woman and Child*, 171 × 241·5cm, 1922

Ferdinand Léger was early indebted to the techniques of Cubism but responded more fervently than Picasso and Braque to the varied visual stimuli of modern city life. He wanted to create a vocabulary of artistic forms that should capture the essence of a culture dominated by the power of technology and the power of the masses. In the *Woman and Child* the mechanical and human elements are integrated; the ordinary anonymous figures are given a kind of nobility, and the energetic contrast of shapes — flat and round, abstract and representational — celebrates the new and vital relationship of man with a man-made world. Later in his life Léger executed a series of large paintings of popular, often proletarian subjects — musicians, cyclists, men building an electricity pylon, and common people at leisure. His drawings became extremely simplified, and he intended these works to have a wide popular appeal.

Shahn: *Mine Disaster,* 61 × 76·3cm, 1948

List of Illustrations

Bibliography

FRIEDLANDER, M J.: *Landscape, Portrait, Still-Life*, 1949
GONCOURT, E. and J. DE: *French Eighteenth Century Painters*, 1958
LEVEY, M.: *Rococo to Revolution*, 1966
NOCHLIN, L.: *Realism*, 1971
ROSENBERG, J., SLIVE. S. and TER KUILE, E. H.: *Dutch Art and Architecture 1600-1800*, 1966